IMAGES
of Rail

ERIE RAILROAD'S NEWBURGH BRANCH

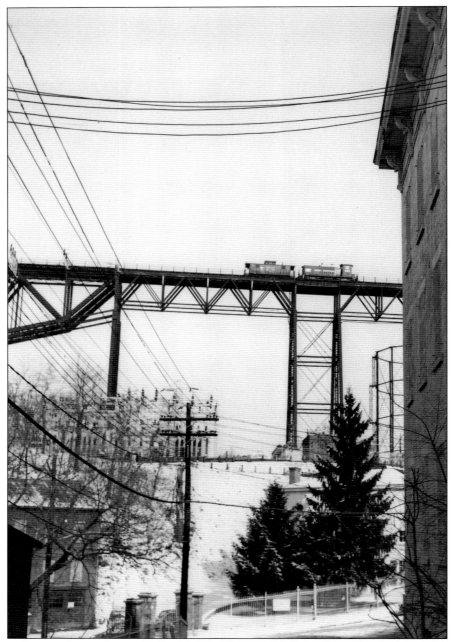

A New Haven caboose hop crosses the Poughkeepsie Railroad Bridge in January 1972. The bridge is 6,727 feet long and stands 212 feet high. On May 4, 1974, a fire on the bridge closed it to rail service permanently. Today, it lives on as the Walkway Over the Hudson. (John Stellwagen photograph; courtesy of the Maybrook Railroad Museum.)

ON THE COVER: An Erie commuter train arrives in Jersey City on May 9, 1950. During rush hour, a train would pass the tower in the background every 38 seconds. (Author's collection.)

IMAGES
of Rail

ERIE RAILROAD'S NEWBURGH BRANCH

Robert McCue

ARCADIA
PUBLISHING

Copyright © 2014 by Robert McCue
ISBN 978-1-4671-2096-8

Published by Arcadia Publishing
Charleston, South Carolina

Printed in the United States of America

Library of Congress Control Number: 2013945012

For all general information, please contact Arcadia Publishing:
Telephone 843-853-2070
Fax 843-853-0044
E-mail sales@arcadiapublishing.com
For customer service and orders:
Toll-Free 1-888-313-2665

Visit us on the Internet at www.arcadiapublishing.com

This book is dedicated to the Ontario & Western Railway Historical Society, the Middletown & New Jersey Railway Historical Society, the Maybrook Railroad Museum, and the Woodbury Historical Society. It is through the dedication and generosity of their members that the rich heritage of Orange County is kept alive.

Contents

Acknowledgments		6
Introduction		7
1.	Railhead Points on the Erie	11
2.	Gateway to the East	31
3.	The Graham Line and the Shortcut	37
4.	The Newburgh Branch	49
5.	Dennis Carpenter's Photographs	69
6.	Penn Central and Conrail	77
7.	The Motorcar Trips	85
8.	Decline and Aftermath	91
9.	Odds and Ends	107
10.	Photograph Gallery	113

Acknowledgments

This book would not have been possible without the support of the following people: Bob Samboothe of the Maybrook Railroad Museum; Richard McKnight, for his access to the Steamtown Railroad archives and the Erie glass-plate collection; Dennis Carpenter, for the use of his personal photographic collection and firsthand accounts of the Erie; my fellow members of the Ontario & Western Railway Historical Society (O&WRHS), Ray Kelly, Russell Hallock, and Doug Barberio, who are always willing to lend their knowledge and continued support; Rich Taylor of the Erie Lackawanna Historical Society; and Alex Prizgintas of the O&WRHS and the Woodbury Historical Society. All maps are from the 1903 Mueller Orange County Atlas, which is part of the author's collection.

INTRODUCTION

In 1807, a strange and wondrous new kind of ship began plying the waters of the Hudson River between New York City and Albany. Instead of being powered by sail, two paddlewheels, one on each side, pulled the ship along. Where a mainmast should be was instead a smokestack. Below the smokestack, out of sight, was something few people at the time had ever seen, and something many thought was from the devil himself. A furnace boiled water to make steam—enough steam to power the paddlewheels. Two crankshafts, one attached to the paddlewheels and one to the engine, connected to a giant walking beam above deck. Watching this beam and its shafts move up and down in cadence with the speed of the ship fascinated the passengers. This ship was Robert Fulton's *Clermont*, and it was the first successful steam-powered vessel. Many called it "Fulton's folly." But, by the end of the 1800s, steam power had virtually replaced sail power on all the major waterways in the world.

For centuries, mines had been running their ore cars along a set of wooden or crude iron rails, pulled by mules. In London and Wales, early "tramways"—carriages pulled by horses along public streets—began running on a set of rails in the early 1800s. Steam power was beginning to come into use to pump water out of mines.

Steam-powered machines of a different sort were soon to propel another wonder of the industrial age: the railroads—a road of iron rails to move passengers and freight for hundreds of miles. Here was a new kind of animal, because a roadbed had to be built across rivers and over (and through) mountains. It had to be solid enough to support a steam-powered engine pulling a string of carriages at the unheard-of speed of four miles per hour. The ride was far from smooth, and sparks from the engine's smokestack showered passengers. Cars loaded with bales of cotton were placed between the engine and passengers because early steam boilers could (and often did) explode. Straps of iron were nailed to lengths of wood to form the earliest rails, but the iron could come loose and spring up through the bottom of the carriages, with deadly results. And, at the end of track came one more problem: all this had to be brought to a smooth and safe stop. Despite all this, train travel still became the preferred method of travel over bone-jarring stagecoaches and unpaved roads that were either hard and rutted or muddy and impassable. Bringing railroads into the modern age would involve a cast of heroes, heroines, villains, and unsung heroes, from the lowliest track worker up to the highest political office.

The New York & Erie Railroad started construction in 1835 and reached Goshen, in Orange County, in 1841. When finally completed in 1851, the Erie was the longest railroad in America, stretching over an area of more than 400 miles from Piermont, on the Hudson River, to Dunkirk, along Lake Erie. One of the fateful decisions on the Erie's route was to run it along the Delaware River, as opposed to going through Sullivan County's Catskill Mountains. Some three decades later, the predecessor to the New York, Ontario & Western Railroad would send its route over

the Catskills. But the torturous grades involved would be a headache to the railroad for all its life. The origins of the Erie go back to a young bride who was so enthusiastic about her first train trip in the South that when she returned with her new husband to their Ramapo, New York, home, her great enthusiasm made sure to catch the ear of her brother-in-law Eleazar Lord. A prominent New York captain of industry, Lord was also a supporter of Clinton's surveys for a railroad. A bride's enthusiasm quite literally set the wheels in motion for the Erie Railroad. Lord would go on to be the Erie's first president.

At the time of the Erie's construction, rails were shipped from England. It was a very expensive and cumbersome proposition. Thankfully, this was just at the time when two brothers were trying to make a go of an iron foundry along the Lackawanna River in Pennsylvania. A deal was made to ship rails from the foundry over the mountains to the Erie. Mules pulled the first wagons of rail, and later the foundry became established enough to construct its own railroad to ship rails with. The two were the Scranton brothers, whom the city of Scranton was named after. The railroad they built was the forerunner of the Delaware, Lackawanna & Western Railroad, one of the Erie's biggest rivals and the railroad the Erie would merge with to form the Erie Lackawanna Railroad in 1959.

In 1801, businessmen from Sullivan County charted the Newburgh–Cocheton Turnpike, running between Sullivan County and the Hudson River. The turnpike opened in 1809 and was a boon to both connecting points. Sullivan's first major commerce had been shipping logs down the Delaware River. The next major export after logging was quarrying bluestone. New York City became a major market for the durable stone for use in sidewalks and curbing. Following this was the next major commodity, coal. In 1829, the Delaware and Hudson Canal opened between the coalfields in Pennsylvania and the port of Rondout, near Kingston on the Hudson River. While the canal was a boon to towns all along it, Newburgh's standing as a port city was seriously threatened by it. Canal boats moved at an average of four miles per hour, pulled along by mules. The advantage was not in speed but in tonnage. The largest canal boats could carry weights that American highways could not match until the 1950s. The coming of the railroads, however, set speed records that no canal could come even close to matching, which brought the age of the canals to a close. The last coal-laden boat traveled up the canal from Honesdale, Pennsylvania, in November 1898. Much of the canal towpath survives today as a linear park.

In the early 1830s, Newburgh came to realize that its future lay in the construction of a railroad. A charter was granted by the State of New York on April 21, 1835, for the Hudson & Delaware Railroad (H&D), with a proposed route of travel from Newburgh "through the County of Orange to the Delaware River." Early planners also envisioned for a time that the new railroad would be the Hudson River terminus of the New York & Erie Railroad, which was also starting construction, reaching as far as Goshen, in Orange County, by 1841. The idea of the Erie using the H&D as its Hudson terminus raised such an outcry from towns and cities along the originally proposed Erie route south of Orange County that the protestors became known as the "Anti-Newburgh group." The protest would prove moot, however, as a full decade passed before the H&D got past ground-breaking.

Salvation finally came in 1845. To keep its state-granted charter, the Erie had to meet its construction deadlines. But it had begun bogging down in both its construction and financing. The state bailed out the Erie with a loan amounting to $3 million. In return, the Erie agreed to construct a 19-mile branch from a junction with the Erie main line, in present-day Greycourt, near Chester, to Newburgh. Newburgh had lobbied long and hard for its railroad, with the biggest support coming from a Newburgh businessman, a transplant from New York City named Homer Ramsdell, who had sold all of his New York City holdings and moved to Newburgh just ahead of the proposed Hudson & Delaware Railroad. Very soon, he became one of the city's most prominent business leaders. In 1845, he still had a 50-year career of public and private service ahead of him. When Ramsdell passed away in 1894, his *New York Times* obituary would credit "the railroad between Newburgh and Chester" solely to his business and leadership skills. Among his many accomplishments, he served as president of the Erie Railroad in the 1850s. It was during his term

that construction began extending the Erie main line to Jersey City, the terminal the Erie would call home until the merger 100 years later.

The Erie's Newburgh branch officially opened on January 9, 1850, a full year ahead of the Erie main line. July 1869 saw the opening of a second Newburgh branch from Harriman, on the Erie main line, to Vails Gate, on the Newburgh branch proper. This 17-mile branch had a more direct connection to the main line then the routing through Greycourt; thus, the new line was forever known as the "shortcut." The two branches acted as a double-track railroad line.

In 1867, the Penn Coal Company opened its piers in Newburgh. Coal would be a major commodity on the branch. The milk business and summer boarders were the mainstays of the shortcut at the dawn of the 20th century. With the coming of the automobile age, however, service on the shortcut fell off and then ended in 1937. Passenger service on the Newburgh branch ended in 1938. During World War I, when the railroads were under the control of the United States Railroad Administration, an agreement was made to ship the coal to more modern facilities in New Jersey. The Newburgh piers were never opened again, and the property was instead sold off. Today, only the abutments alongside Water Street tell of the bustling coal business that once existed there.

In 1889, the Central New England Railroad (later the New Haven Railroad) opened its railroad bridge over the Hudson at Poughkeepsie. Before the bridge, the Erie had ferried railcars across the Hudson at Newburgh. The opening of the bridge rendered the car ferry service obsolete. But it also ushered in the era of Maybrook rail yard, one of the largest rail yard facilities on the East Coast at its peak in the mid-20th century. Five other railroads besides the Erie would call on Maybrook rail yard in its heyday: the New Haven; the Lehigh & New England; the Lehigh & Hudson River; the New York, Ontario & Western; and the New York Central.

To access the connection with the Central New England Railroad, Erie trains had to share the Erie's single-track Montgomery branch, from Campbell Hall to the Erie main line at Goshen, with the Lehigh & New England Railroad, another major freight carrier, whose major commodities were anthracite and cement. Beyond Goshen on the Erie main line, there were the tight curves, grade crossings, and stiff grades to contend with; an outmoded route for the amount of traffic that the Maybrook connection would soon be bringing in from the New England states. In 1909, the Erie's 42-mile, low-grade, high-speed freight line was opened through Campbell Hall. Work on the line had started in 1906 and stopped briefly in 1907, when construction bonds could not be sold because the country was in a financial downturn. The line was soon renamed the Graham Line, after its chief engineer, James Graham. Graham died in 1909, living just long enough to see the new line opened.

The workhorses of the Erie's high-speed freight business from the 1920s into the diesel era were the Erie's Berkshire locomotives. The "Berks," as they were known, had 70-inch-diameter drivers, 28.5-inch-by-32-inch cylinders, 225-pounds-per-square-inch boiler pressure, and a tractive effort of 71,000 pounds. The Erie owned 105 Berkshires, one of the largest steam fleets in the country. The "Berks" have been called some of the most handsome-looking steam locomotives ever designed.

After the Erie-Lackawanna merger, local business on the Newburgh branch stayed fairly solid into the 1970s; however, by the start of the 1980s, it was all but over. Conrail took over operation of the Erie Lackawanna and five other bankrupt rail lines in April 1976. Service between Greycourt and Vails Gate ended in 1977. The rails lay forgotten until the fall of 1983, when scrapping operations began. At the same time, the Erie main line between Middletown and Harriman was also scrapped. In those last years before the rails were pulled, a dedicated group of railfans realized what was being lost and, with their own time and resources, traveled the rail lines Conrail was abandoning. With both photographs and film, they recorded the old order as it stood one last time. Today, the old Erie main line is now a popular rail trail. The Graham Line was refurbished in 1983 and carries commuter trains. The roadbed between Greycourt and Vails Gate is intact but gradually reverting back to nature. The five-mile stretch of the Newburgh branch from Vails Gate to Newburgh remains but with limited service. It awaits its fate in an era where economics are seeing the return of rail service as an alternative to overcrowded highways.

In 1981, the Erie's Newburgh branch was long out of use, but it was still intact. The station at Washingtonville was standing, as it had for a century, right down to the signboard on the depot. Only the heavy brush growing over the rusted rails told of the one key element missing. I was 16 years old and on my bike when I first came across this corner of the world, which seemed frozen in time. In the days before the housing boom changed Orange County permanently, the eight-mile bike ride out to Washingtonville was truly a ride in the country. In the years that followed, I came back time and time again, as bike rides turned into daylong hikes out on the roadbed. The removal of the tracks cleared the roadbed of brush for the first time in many years. It takes about two and a half hours to make the eight-mile walk from Cornwall to Washingtonville. That now-familiar depot roofline sticking up from behind the trees became like a greeting from an old friend. Standing just yards from the old roadbed today, I look at the traffic that clogs Washingtonville and wonder about what might have been. With every empty railroad bed and every lonesome depot is a lesson to be learned.

My first walk on the Erie roadbed all those years ago was only the first piece in a giant puzzle. Every writer starts out thinking they have a firm knowledge of their subject. It is every day that comes after that teaches one different. I can say with the utmost pride and affection that every revision I have made or will make as new pieces of the puzzle continue to come in only remind me that, even after more than 20 years of writing, I am still an apprentice at this craft.

One

RAILHEAD POINTS ON THE ERIE

This is a 1935 timetable for both the Newburgh branch (right) and the "shortcut" (left). By the time this timetable appeared, the effects of the automobile age were already apparent. Gas-powered motorcars were used in the last years in an attempt to offset operational losses. (Author's collection.)

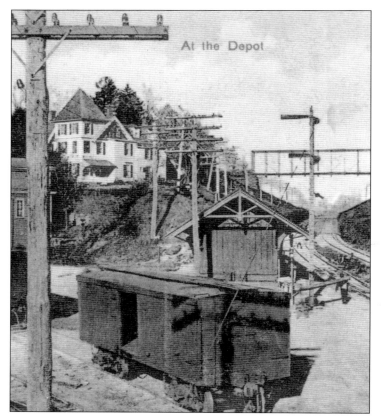

At left is an early postcard of Chester station. When it was first opened, all trains on the Newburgh branch used this station, which is about a mile west of the junction of the branch and the Erie main line. What is now known as Greycourt was called "West Junction" on the early employee timetables, and "East Junction" referred to the wye with the Erie main line. Greycourt would not come into its own as a station stop until the Warwick Valley Railroad reached Greycourt Meadows in 1862. Below is the Queen Anne–style union station that served until passenger service on the branch ended. (Both, author's collection.)

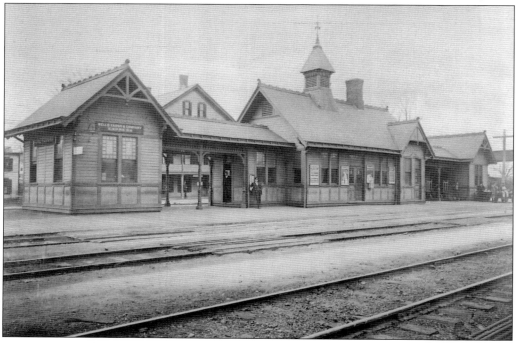

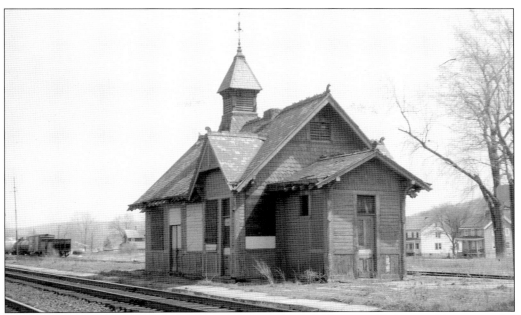

Dennis Carpenter worked on the Newburgh branch, as did his grandfather, and he amassed a lifetime of pictures and memories. By the time he took this photograph in the late 1960s, the abandoned Greycourt station was a forlorn shadow of its former glory. The station vanished not long after this photograph was taken, and service on both the Newburgh branch and the Erie main line only lasted for another decade. (Dennis Carpenter.)

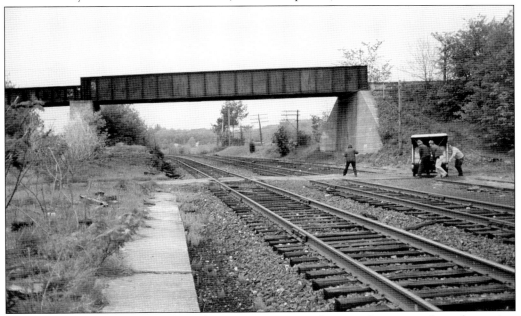

A railfan motorcar trip on the branch in 1983 pauses on the main line across from the station site. Greycourt station's concrete platform is still visible to the left, under the brush. A rail spur still serves customers here today, and the Erie main line is now the Orange County Heritage Trail. (Joyce Sternitzke.)

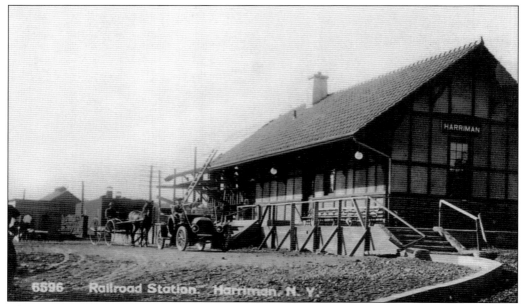

These two photographs show Harriman station, which was constructed in 1911. Trains leaving the shortcut stopped here after coming off the wye with the Erie main line. Originally named Turners, the change to Harriman, a tribute to railroad magnate E.H. Harriman by his widow, at first caused some controversy among village residents, and the station signboard was changed back and forth several times before Harriman became permanent. The first station here was a massive hotel that was destroyed by a fire in 1873. The station that replaced it was an unattractive structure that this 1911 station finally replaced. (Above, Alex Prizgintas; below, author's collection.)

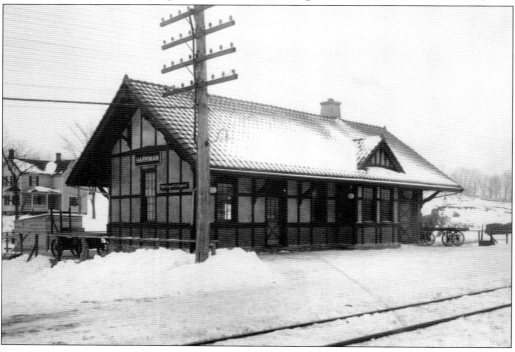

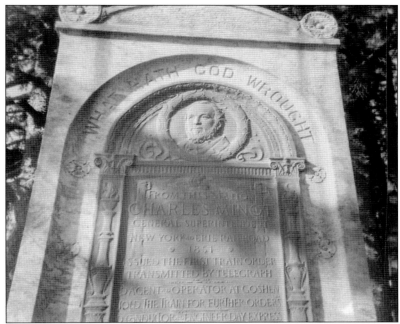

This monument was erected by the Harriman station to commemorate the first use of the telegraph in 1851 to issue train orders. The orders were given by Erie superintendent Charles Minot to the operator at Goshen to "Hold for further orders to Conductor and Engineer day express run to Goshen regardless of opposing train." Mrs. Harriman's arrival for the monument dedication on May 2, 1912, included two special trains and 400 guests, including Thomas Edison and the niece of Charles Minot. Residents and local officials turned out for the grand occasion, along with 100 schoolchildren. The stone for the monument came from the Harriman estate and was paid for by Mrs. Harriman. (Both, author's collection.)

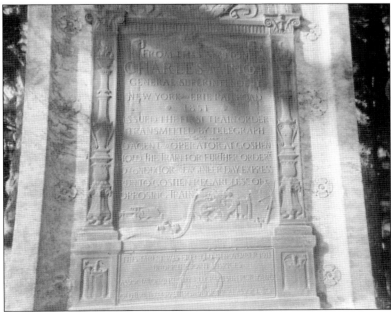

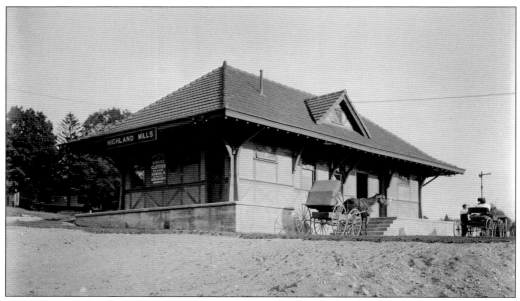

This photograph shows the station at Highland Mills, the second station stop on the shortcut. After 1905, this became the junction point where the shortcut and the Erie's new low-grade freight line, the Graham Line, went on their separate routes. Both shared the three miles of trackage from Harriman to Highland Mills. To the right of the station is the roof of the switch tower that guarded the junction. (Steamtown National Historic Site.)

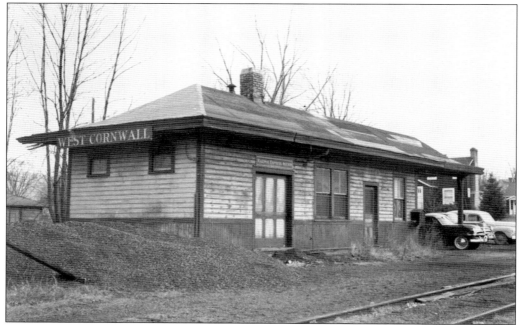

West Cornwall was the last stop on the shortcut before Vails Gate. This was not a junction point, but when service on the shortcut ended, a two-mile spur from Vails Gate was left to service a local coal dealer here. This was Cornwall's first station stop before the opening of the Ontario & Western Railroad and its nearby station at Orr's Mills. (Joyce Sternitzke.)

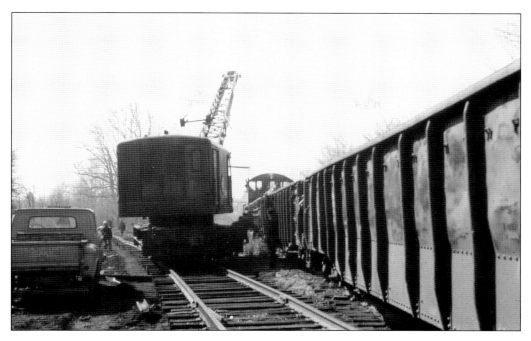

These two photographs show Vails Gate Junction in the 1960s. Only a couple of years after service to West Cornwall ended and the rails were removed, Tarkett Manufacturing moved to Vails Gate. To service the new facility, a spur just over a mile in length was relaid on the old bed of the shortcut. The service remained active under Conrail into the 1980s, when Tarkett closed. Past the crane is the bridge of the New York State Thruway. The bridge was removed very soon after the connection to Greycourt from Vails Gate was cut in 1983. (Both, Dennis Carpenter.)

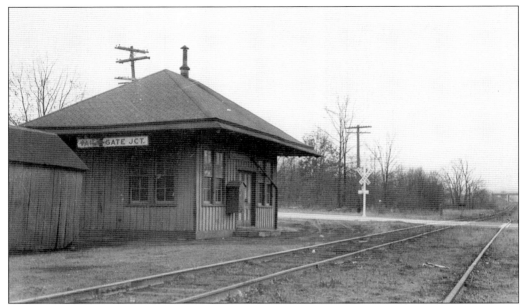

Joyce Sternitzke took these two pictures of Vails Gate Junction and station in the late 1950s. In the distance in the image below is the New York State Thruway's bridge over the Newburgh branch. Although not very visible, the switch to the shortcut, now a spur to West Cornwall, was before the bridge on the left. A passing siding once ran from here to the grade crossing of Route 45 (now Route 94) on the branch, just over a mile in distance. In the 1920s, the switch tender here had a bad leg, so he used a bicycle to perform his switching duties. (Both, Joyce Sternitzke.)

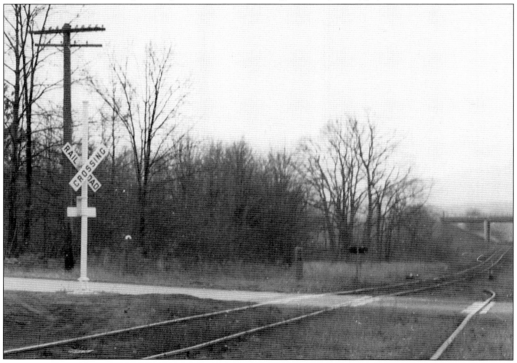

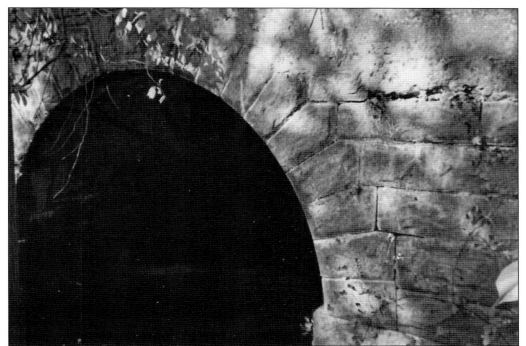

Above is a stone culvert just west of Vails Gate Junction. This kind of stonework can still be found all along the Erie, usually in virtually the same condition as when it was built—a tribute to the craftsmanship of a bygone era. The map below shows the branch on the last five miles into Newburgh. The whole line of the Newburgh branch passes through an area filled with historical structures and places that date back to the earliest days of American history. The Revolutionary War ended barely three-quarters of a century before the Erie Railroad came on the scene. (Both, author's collection.)

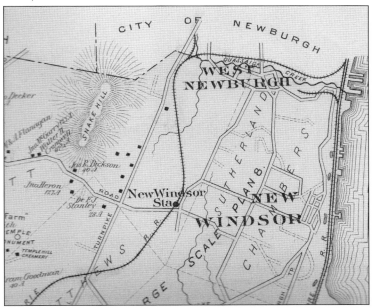

NEWBURGH....
THE SCENIC and INDUSTRIAL CENTER of the
MID-HUDSON REGION

• ——— •

Sixty miles from New York City in the beautiful Hudson Highlands.
Served by Five Railroads, Bus and Boat. 24-hour Ferry Service.
A National Truck Transfer. Two Miles of Water Front. Good Sites.

TELEPHONES: 5100-5101

Complete data, cheerful cooperation and wholehearted assistance will be given by NEWBURGH CHAMBER OF COMMERCE, 44 Montgomery Street, Newburgh, N. Y.

The ad above was for Newburgh in 1948, when it was still advertised as being connected to five railroads. The map below shows the Newburgh engine house on Lake Street, near the New Windsor-Newburgh line. This was located just where the branch curves into the long downgrade to Newburgh. The engine house was removed in the 1930s, but the turntable, which was hand-turned, survived into the late 1940s. One of the reasons the engine facilities were located here was that a weight restriction on the bridge over Renwick Street in Newburgh did not allow the heavier motive power that was used on the Erie's coal trains. The engine house and turntable site are occupied by a lumberyard today. (Both, author's collection.)

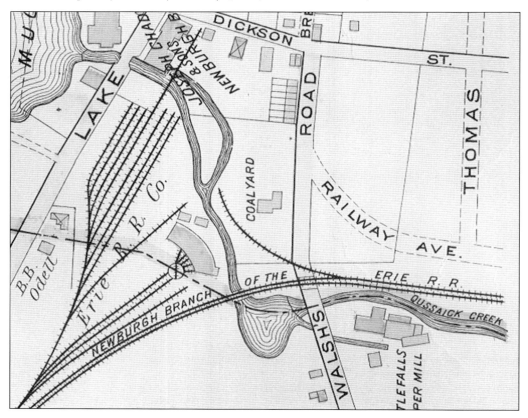

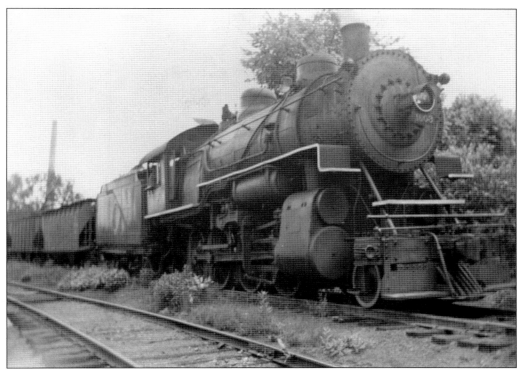

Above, engine 1603 is doing switcher duty on the Newburgh industrial spur. The smokestack for Dupont is in the left background. The spur branched off near the engine facilities and crossed Lake Street to serve Dupont, Strook, and scores of other Newburgh businesses, from newspapers to lumber dealers. The switch from Dupont was cut back when it converted from coal in the 1940s. The last customer, Miron Lumber, closed in the 1980s. Below, a local has crossed Robinson Avenue (Route 9W) on the Dickson Street spur, another line servicing a number of local businesses into the 1980s. (Both, Dennis Carpenter.)

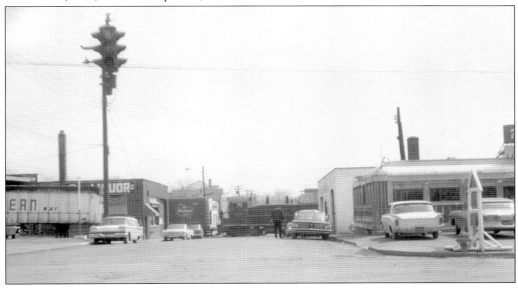

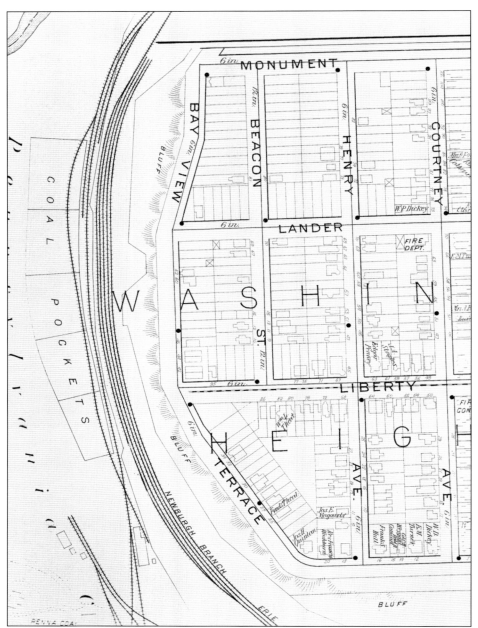

The 1903 Mueller Orange County Atlas gives an idea here of the amount of railroad activity on this portion of the branch in the early 20th century. The coal pockets are part of the Penn Coal Company's facilities, constructed in the 1860s. Today, the abutments that flank Water Street are the only surviving remnants of the coal piers and pockets. Of the three tracks on the branch itself, one was a safety track, built on the chance that a freight car became a runaway on the hill. The operating rules mandated that the switch and derail (a metal device locked onto the rail) were always set for the siding. This would throw a runaway off the rails before it rolled down into the yard and station area. Train crews were required to stop, turn the switch, and then reset it behind them. (Author's collection.)

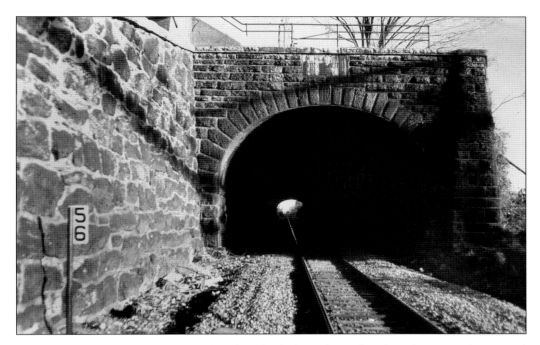

When the West Shore & Buffalo Railroad was built through Newburgh in the 1880s, the original plan was to go around the Erie and pass above Newburgh's Front Street on an elevated viaduct. This plan was dropped amid the protests of the business owners along Front Street, and the tracks were moved just to the west. For this, the West Shore was forced to construct a tunnel under the Newburgh branch. In the 1980s, the tunnel was daylighted to allow access for higher railroad cars. A trestle for the old Newburgh branch was constructed, and then the embankment was removed and the top of the tunnel was taken off. (Both, Russell Hallock.)

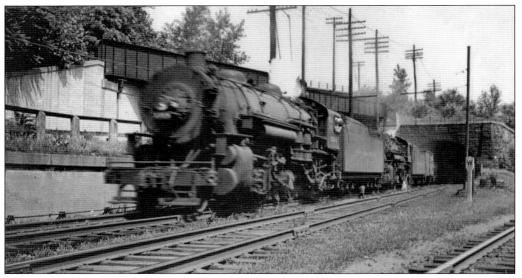

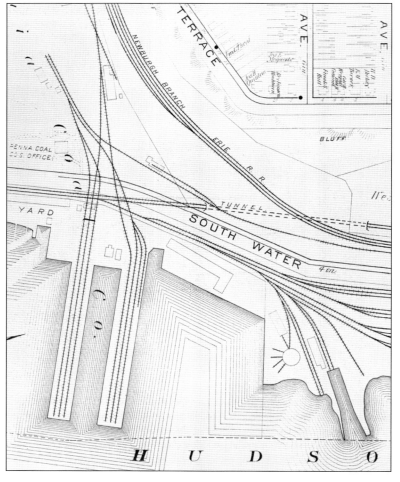

A West Shore doubleheader is seen (above) passing through the tunnel at speed. The track to the right leads to the West Shore yard. To the left, above the engine, is the trestle for the Erie. The coal piers would have crossed at this location, just before the mouth of the tunnel. Although Water Street passes under the Erie here, the tracks originally crossed over Water Street, as can be seen on the map (at left). In another era, the street crossed the West Shore at grade, to go around the Erie, making for a treacherous railroad crossing. (Both, Jim Green.)

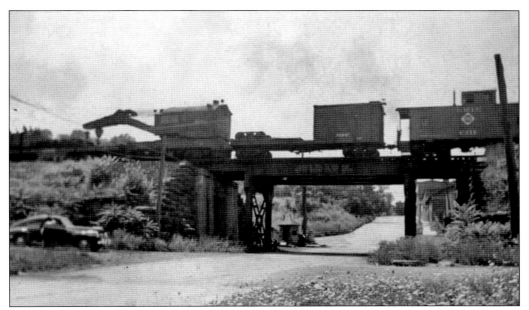

Dennis Carpenter took this photograph of a wreck train on the bridge over Renwick Street. A freight car had derailed at the Armour plant in Newburgh, and this train was dispatched to re-rail it. On the bridge are the words "Erie Railroad-New York-Chicago." There were still no crossing gates installed, and a crossing guard and his shanty still protected the West Shore tracks behind the bridge. (Dennis Carpenter.)

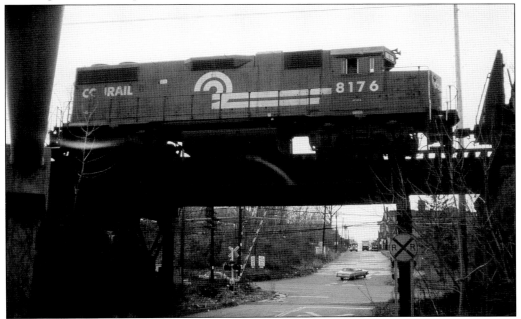

The bridge over Renwick Street is seen here in the Conrail era. There was no service between Vails Gate and Greycourt after 1977, but the five miles from Newburgh to Vails Gate were still seeing a fair amount of business. Up on the roadbed, the ties for the long-vanished second track remain to this day. (Russell Hallock.)

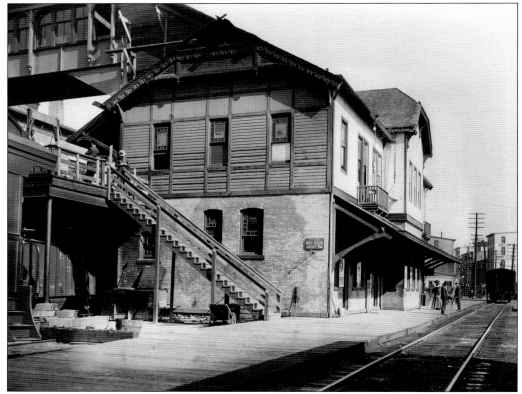

The station above was built by the West Shore and the Erie and was opened in 1882. The Erie is on the lower level, at Front Street, and the West Shore is on the second level, along Water Street. The structure coming off the station to the upper left is a walkway over the West Shore tracks to an annex station on Water Street. The West Shore replaced the annex with its own brick-and-stone station in 1912. The two-story station was removed not very long after the Erie dropped passenger service in 1938. In the Russell Hallock photograph below, the West Shore station can be seen in the background, above the railfan special, in the 1960s. (Above, author's collection; below, Russell Hallock.)

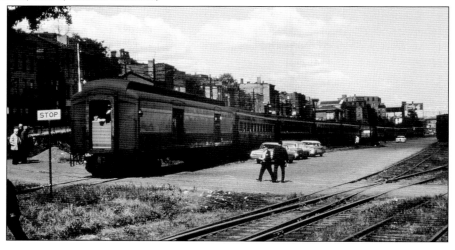

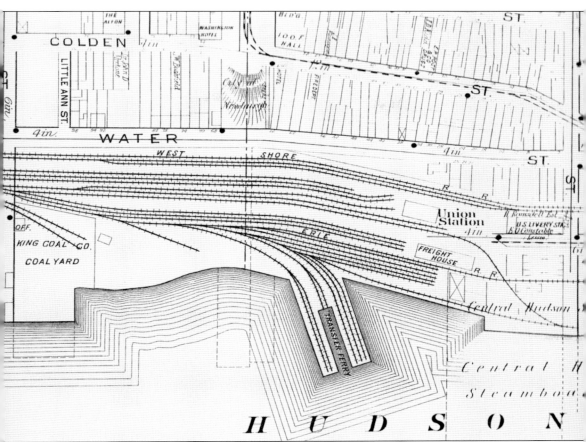

The Erie's Newburgh yard is seen here around 1900. The Erie/West Shore station is towards the center. The Hudson River car floats are on the right. When the Penn Central took over operations of the West Shore line in 1968, the switch that connected the Erie yard to the West Shore was reversed, cutting the direct connection between the two railroads. When Conrail took over both railroads, the switch was turned back since Conrail would now be serving the spur to Vails Gate. Several plans were talked about for the Newburgh branch in connection with other railroads, but none ever materialized. Today, a steam crane still stands on the side of the old Erie yard near the West Shore, and the rest of the yard is public parking. Rails can still be found in the pavement. (Author's collection.)

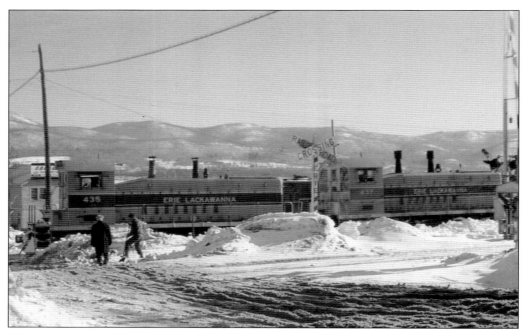

Erie Lackawanna switchers 435 and 437 are seen in these photographs in Newburgh in the winter of 1971. Engines 435–438 were built for the Erie in 1952 by the Electro-Motive Division (EMD) of General Motors, with builder's numbers 15933–159336. By the 1970s, the overwhelming competition from highways and airlines, combined with the decline of American manufacturing in the Northeast, made for hard times for the nation's railroads. The merger of the Erie with five other railroads into Consolidated Rail Corporation (Conrail) occurred in 1976, five years after these photographs were taken. (Both, Dennis Carpenter.)

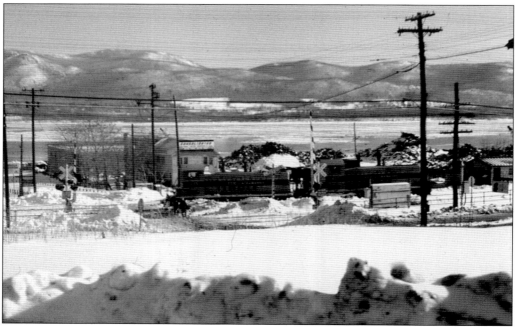

Engine 437 was still in Erie colors in the late 1960s. Above, it is working the "night haul." Behind it are the lights to the Erie's piggyback truck terminal. Trains would pick up the piggyback cars at Campbell Hall and bring them for unloading at Newburgh via the Erie's Montgomery branch, the Erie main line, and the Newburgh branch run. The cars could only be unloaded from one direction, so care had to be taken at Campbell Hall to make sure the cars were turned correctly. A mistake meant having to risk the wrath of the dispatcher to get clearance to make a fast run back to the wye at Campbell Hall. Below, the 437 is seen at Vails Gate during the building of the Tarkett spur in the 1960s. (Both, Dennis Carpenter.)

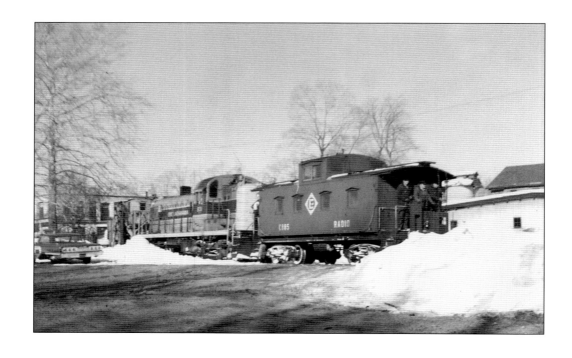

The photograph above, taken at the Erie/Erie Lackawanna power, shows Erie Lackawanna 931 at the end of the West Newburgh industrial track shoving a Jordan Spreader snowplow at Dupont and Wisner Avenues. All that remains of this one busy spur are remnants; a few sections of track remain in the overgrowth, and there is still a bridge over the creek near the former Strook plant. Strook was a major clothing manufacturer, and Dupont's Fabrikoid, marketed as artificial leather, was popular in the 1920s on everything from books to car tops. Below is a 1948 advertisement for Strooks. (Above, Dennis Carpenter; below, author's collection.)

S. STROOCK & CO. INC.

RETAIL STORE

Wearing Apparel for Men, Women and Children

AMERICA'S MOST DISTINGUISHED WOOLENS

Broadway and Wisner Avenue Telephone 1801

Two

GATEWAY TO THE EAST

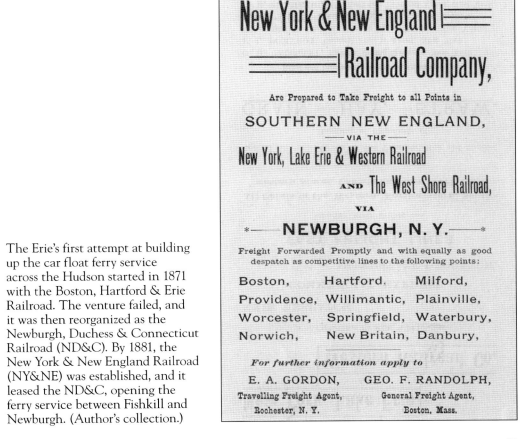

The Erie's first attempt at building up the car float ferry service across the Hudson started in 1871 with the Boston, Hartford & Erie Railroad. The venture failed, and it was then reorganized as the Newburgh, Duchess & Connecticut Railroad (ND&C). By 1881, the New York & New England Railroad (NY&NE) was established, and it leased the ND&C, opening the ferry service between Fishkill and Newburgh. (Author's collection.)

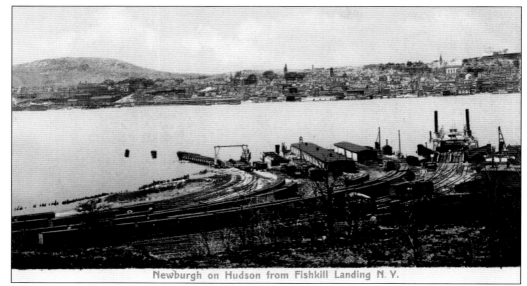

The postcard above shows the car float service from Fishkill. To the right is the best-known transfer ferry, the *William T. Hart*, named for a president of the NY&NE. At the time the *Hart* went into service in 1881, it was the second-largest ferryboat in the world at over 300 feet in length. A crew of 24 men was required to operate the ferry, which could carry up to 27 freight cars at a time. It was paddle wheel driven, and its powerful engines could turn it around in the space of its own length. Below, a Maybrook-bound freight stretches out across the length of the Poughkeepsie Bridge behind steam power. Maybrook yard grew to encompass six separate yards, three for incoming trains and three for outgoing trains, plus a full repair complex and a YMCA. (Above, author's collection; below, Maybrook Railroad Museum.)

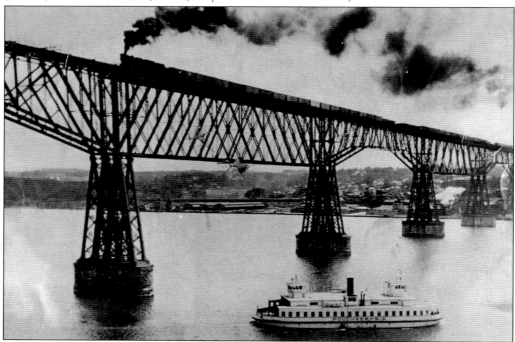

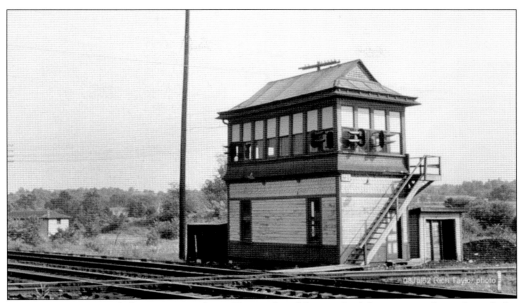

MQ Tower protected the crossing of two Erie railroad lines: the Montgomery branch and the freight-only Graham Line. This crossing was used by the Erie; the New York, Ontario & Western; and the Lehigh & New England. By the time this photograph was taken in 1962, only the Erie (now the Erie Lackawanna) remained. (Rich Taylor.)

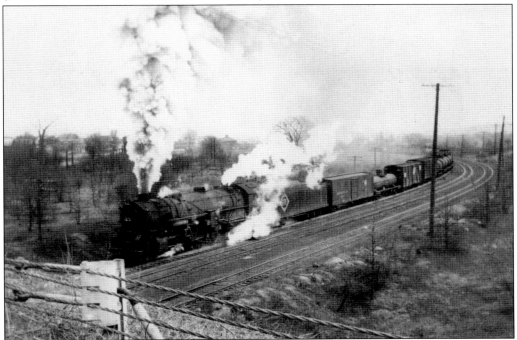

Fred Carpenter, the father of Dennis Carpenter, took this photograph of train 9, with an Erie Berkshire on the point, as it pulls out of Maybrook yard and is about to pass under the Route 208 bridge. It was March 1946, and the world was enjoying the first peacetime spring in a decade. (Dennis Carpenter.)

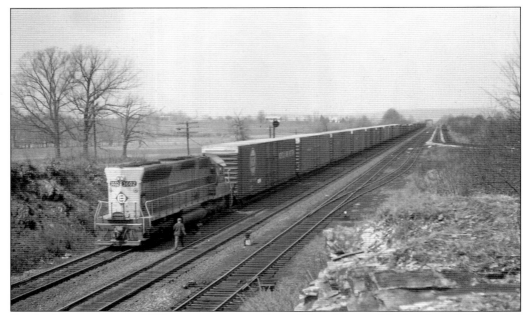

Erie Lackawanna engine 3602 is setting out cars that will be taken into Maybrook yard. The end of its train is out of sight in the distance beyond the O&W Bridge. The Ontario and Western Railroad has been gone since 1957, but the O&W Bridge remains to this day. (Dennis Carpenter.)

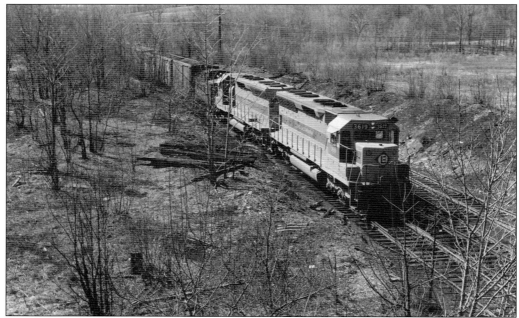

John Stellwagen took this photograph in May 1968 of an Erie freight coming into Maybrook yard. Out of sight behind the train, the tracks pass under the Route 208 bridge. The Lehigh & Hudson River entered the yard on its own main line and under another bridge on Route 208. (Maybrook Railroad Museum.)

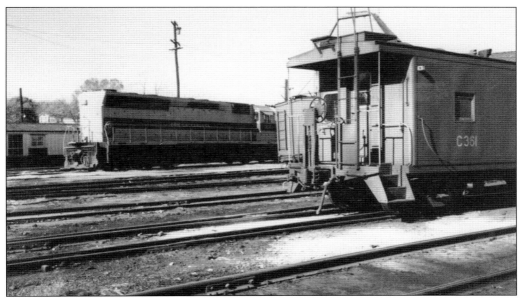

Above, an Erie Lackawanna engine and a nearby caboose await their next assignment. Below, Erie Lackawanna engine 3630 pauses next to the Maybrook shops. Both photographs were taken in November 1971. By that time, the New Haven's Poughkeepsie Bridge route had become part of Penn Central. The Penn Central came into Maybrook as a service of the New Haven, but Penn Central management was concentrating its efforts in the expanding yards at Selkirk (Albany)—a bad omen for the future for the Lehigh & Hudson River (L&HR) and the Erie Lackawanna's Maybrook service. After a fire on the bridge in 1974, Penn Central officials were quoted saying, "It will take four to six months to repair the Poughkeepsie Bridge." A spokesman for the railroad also commented, "Our engineers have determined that there is no structural damage to the bridge and that freight service will be continued after repairs are made." (Both, Maybrook Railroad Museum.)

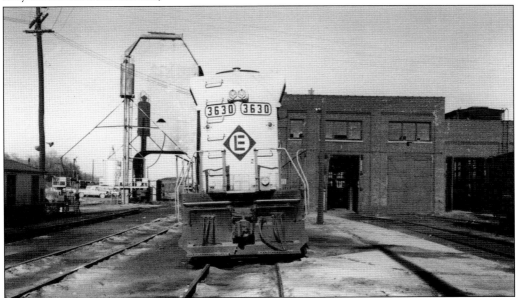

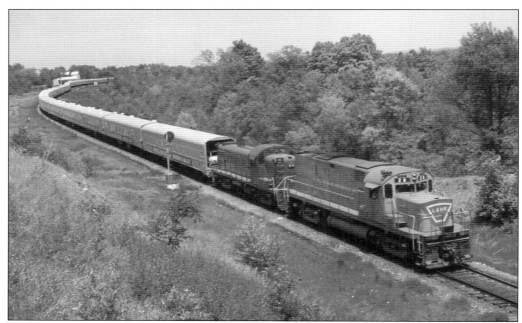

This circus train is seen leaving Maybrook behind L&HR power in the 1960s. The annual arrival of the circus train in Maybrook was a tradition that was always looked forward to. The loss of the connection to the New England states via Maybrook made the circus trains just a fond memory and pushed the Erie Lackawanna and the L&HR that much closer to the brink. (Dennis Carpenter.)

This photograph was taken in August 1971. The quiet yard is a far cry from the record set during World War II, when 25 eastbound trains (1,665 cars) and 29 westbound trains (1,826 cars) were switched through here in a 24-hour period. (Maybrook Railroad Museum.)

Three
THE GRAHAM LINE AND THE SHORTCUT

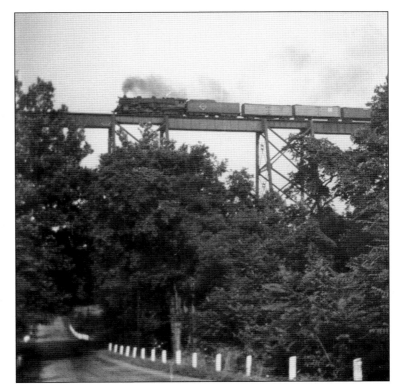

In 1945, this eastbound express freight was photographed crossing the Moodna Viaduct. The Graham Line was planned as a two-track line, but when construction stopped for a time in 1907, it left the Erie with neither enough time nor enough money to double-track a bridge that size. The design of the viaduct left room to add a second track in the future, but that never occurred. (Dennis Carpenter.)

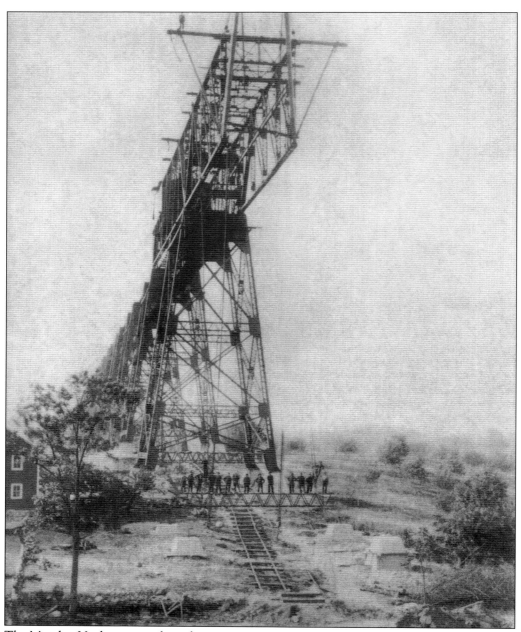

The Moodna Viaduct is seen here during construction. The viaduct is 3,200 feet long and stands 195 feet at its highest point. To construct this massive bridge without the time and expense of wooden falsework, a "traveler" was built to move along the rails. The steel was raised in each span until that section was completed, and then the tracks were laid down and the traveler moved to the next span. This was the last piece of the new rail line to be completed, opening in January 1909. James Graham, the rail line's chief engineer, passed away that February of "acute indigestion." After more than 100 years of service, this impressive structure has the distinction of being the longest active railroad trestle east of the Mississippi. It is presently undergoing renovations on its concrete and steel work. (Stephen Steiner.)

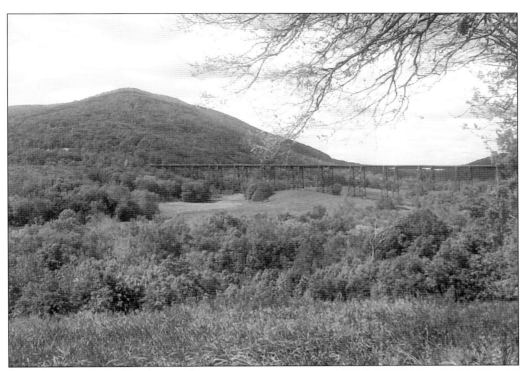

Seen above in the left background is Schunemunk Mountain. The area behind the trestle was the site of the slope of the Norseman's Ski Club. The Erie ran ski trains on the Newburgh branch to Salisbury Mills through the 1930s. Out of view here, under the highest section of the span in the center, are Moodna Creek, Orrs Mills Road, and the Newburgh branch. This view of the viaduct, looking from Orrs Mills Road, has been immortalized in both paintings and photographs. The photograph at right is where the railroad bed of the Newburgh branch passes underneath, with a railfan trip on the point. (Both, author's collection.)

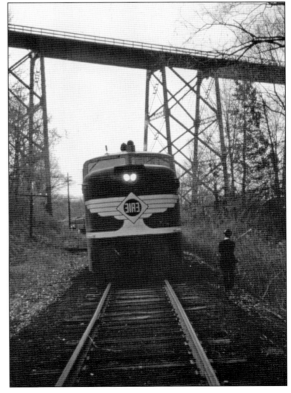

The photograph above shows the original underpass for Route 45 (now Route 94). Around 1900, trolleys were the only competition to the railroad. A proposed trolley line between Newburgh and Goshen would have been a serious threat to the Erie's business. So, when the Graham Line was constructed, this concrete "tunnel" was built west of the highway, making it reroute through a hairpin turn. The turn was sharp enough that no trolley track could have negotiated it. In the 1930s, the hairpin turn was eliminated when a new highway underpass was built on the old highway bed. In the photograph below, steam returns to the valley with Chesapeake & Ohio locomotive 614 leading a railfan trip in the 1990s. (Both, author's collection.)

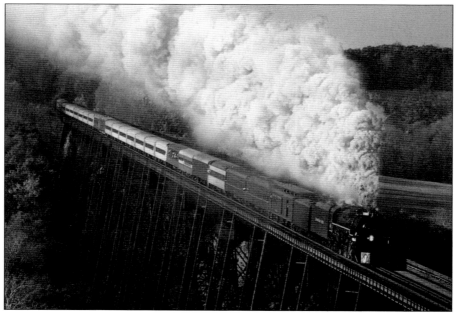

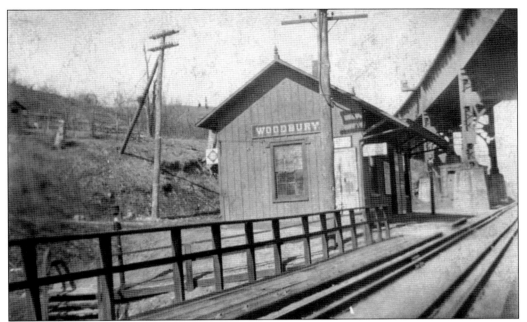

At Woodbury, the Graham Line spans Woodbury Creek, the state highway (Route 32), and the shortcut. When the highway was realigned in 1937, the Woodbury station was torn down, and the highway was cut through the embankment where the station had stood. In 1900, the Erie was shipping 900 quarts of milk from the Woodbury station. (Dennis Carpenter.)

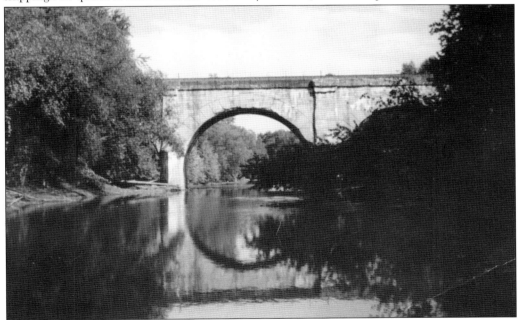

Just past Campbell Hall, the Graham Line crosses the Wallkill River on this impressive concrete structure. Back at Campbell Hall, a steel truss bridge on the Graham Line crosses over the O&W railroad bed. This photograph was taken from the site of the O&W's Wallkill River bridges. (Author's collection.)

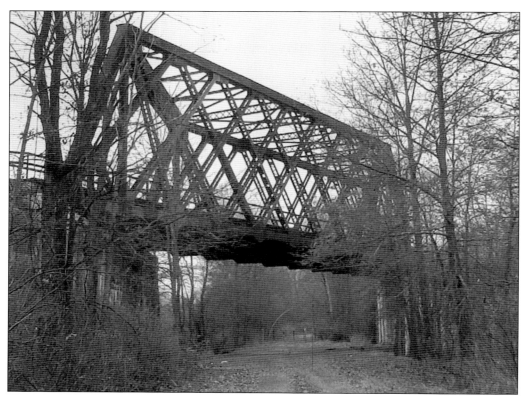

This is the Graham Line's bridge over the O&W at Campbell Hall. This section of the right-of-way is now preserved as part of the Hamptonburgh Nature Preserve. The bridge piers for the O&W's Wallkill River bridges are still intact, but the trail does not go all the way to the river because of overgrowth and private property lines. (Author's collection.)

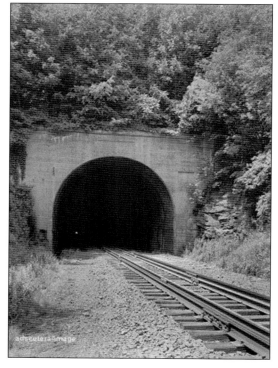

The 5,314-foot-long tunnel at Otisville was started in 1905 with a central shaft drilled so the tunnel could be started in four directions simultaneously. It opened in October 1908. Originally made up of two tracks, additional clearance was gained in 1954 by gauntleting the track through it, as seen here. *Gauntleting* refers to merging the two tracks without the need for switches. (Author's collection.)

Two famous Erie locations are seen here. Above, in 1910, is Howells, once the junction of the double-track Erie main line and the double-track Graham Line. Since then, the connection to Middletown has been rerouted to two miles south of here via the O&W right-of-way into Middletown. A new roadbed was graded down to the Graham Line where the O&W formerly crossed over it. The old junction at Howells is no more. Below is Black Rock Cut and Rundell's curve on the long downgrade coming into Port Jervis. In the steam era, it would take pusher engines, sometimes two or more strong, to get a heavy train up to the top of this grade at Guymard, the starting point for the Graham Line. The line itself was originally called the Guymard cutoff when it was first constructed. (Both, author's collection.)

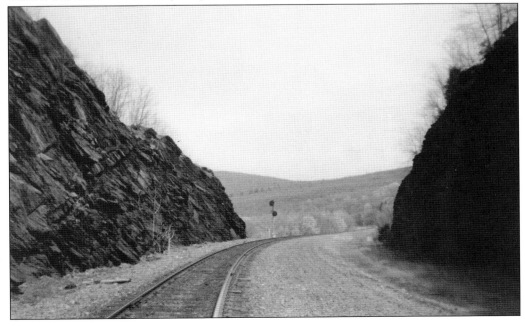

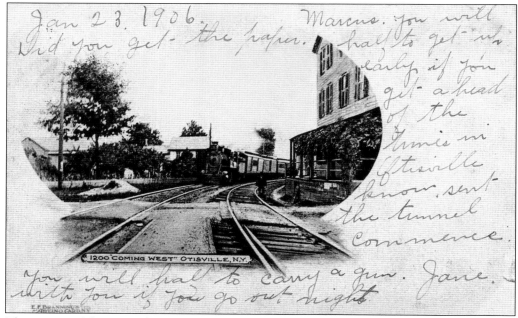

The portion of the original Erie main line that went through Otisville in the postcard above was abandoned in 1954, and all main line service was shifted to the Graham Line. A spur was left to come into Otisville to serve local industry. This postcard is dated January 23, 1906, when the construction of the tunnel below the village was underway. The last comment on the postcard reads, "Since the tunnel commenced you will have to carry a gun if you go out at night." The rock cut in the photograph below was part of the original 1850s Erie main line through Otisville. Some of the remnants of this now-long-abandoned spur could still be found when the image was taken in 1991. This rock was cut in the days before dynamite, when black powder and human muscle were the method used. The roadbed was still well preserved in 1991. (Both, author's collection.)

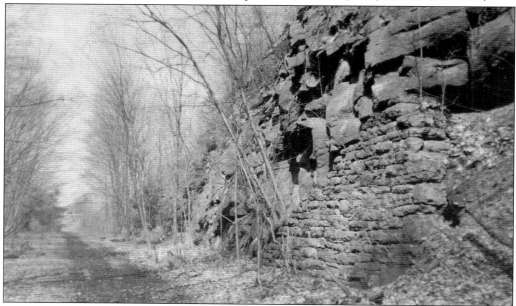

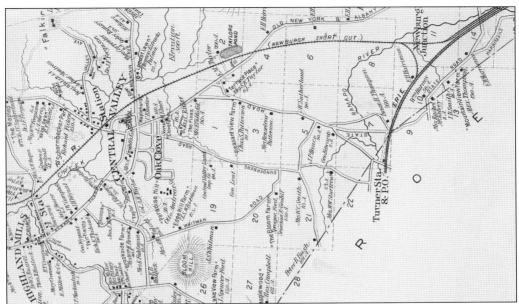

Leaving the Erie main line at Harriman, the shortcut (and later the Graham Line) first passed through Central Valley to Highland Mills, where it makes its next stop at Woodbury and then continues on towards Mountainville. The shortcut runs alongside Woodbury Creek and Moodna Creek, both of which were, and still are, well known for their trout fishing. Halls Fishing Lines, based in Highland Mills, was world-renowned for its fly-fishing equipment. (Author's collection.)

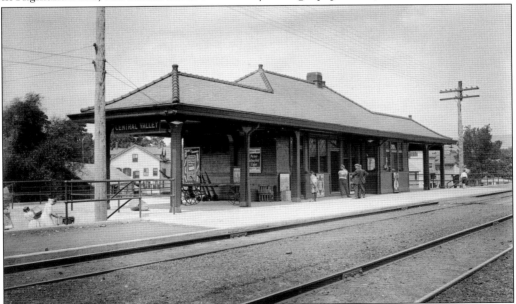

When the Graham Line was being planned, the Erie was mandated by both state and local officials to place it above any of the town highway crossings. So, the entire three miles of track from Harriman to Highland Mills was rebuilt and raised. The Central Valley station was moved and raised up to the level of the new line, where it remains today even though it is no longer railroad property. (Steamtown National Historic Site.)

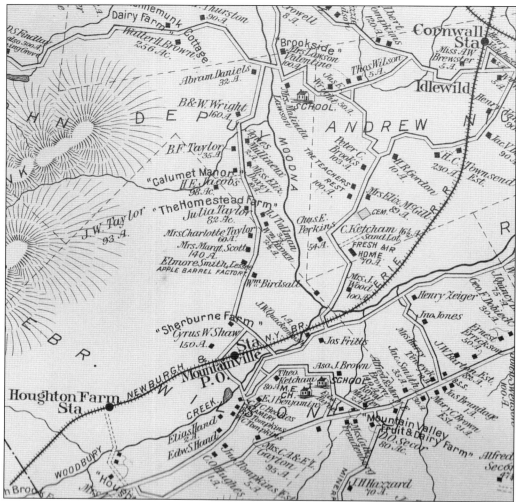

Houghton Farm, the next stop on the line after Woodbury and before Mountainville, was a milk station and a model working farm, with exhibits and demonstrations. It was also a summer hotel, and painter Homer Winslow used the farm and its surrounding landscape as a backdrop for many of his most famous works. Cornwall author E.P. Roe used Houghton Farm as the setting for his book *Return to Eden*, the story of a family that moves to "Maizeville" to help their children escape the evil influences of the city. The Houghton property was taken over by another farm in the 1930s. When the New York State Thruway was built through the area in the 1950s, the Houghton Farm station was moved up on the property to near Route 32, where it still stands today. The thruway cuts across the old roadbed, and a factory stands on the site of the former Houghton Farm station. (Author's collection.)

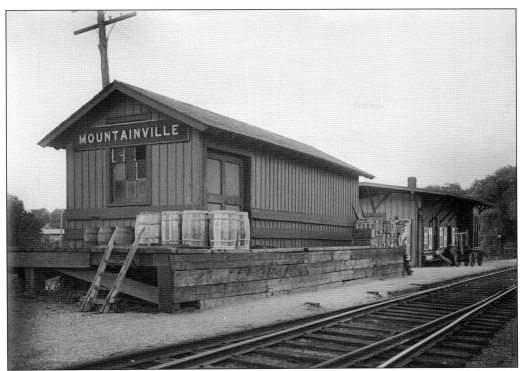

Mountainville was a busy railroad stop, with summer hotels, a creamery, and a cider mill. In 1889, the *Cornwall Local* noted that the creamery at Mountainville was producing 1,348 bottles of milk a day. When the railroad closed, the station was sold and became a public library, a capacity it served in for over 50 years. The station survives today, but the freight house is gone. Ketcham's store was a local fixture, and Mountainville was originally named Ketchamtown. The name was changed to Mountainville when the railroad arrived. John Orr took over the operation of Ketcham's mill around 1900, and the mill still stands today as a private club and local landmark. The sturdiness of the mill's construction has proven itself time and time again, standing steadfast against Moodna Creek when the waters are at flood stage. (Both, author's collection.)

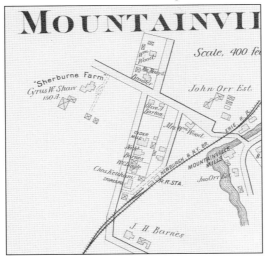

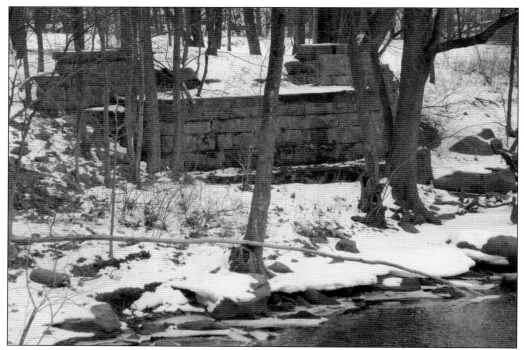

Seen here is one of a set of well-preserved abutments located a mile outside of Mountainville, which carried one of the bridges for the shortcut over Moodna Creek. The great flood of October 1903 wreaked havoc on every business and railroad in the area, with service on the shortcut being out for the better part of a week. (Ray Kelly.)

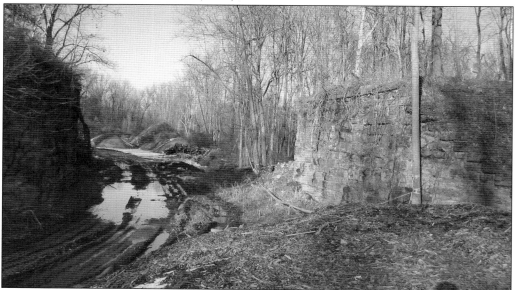

The O&W crossed over the shortcut at Enderlin, seen here. The thruway passes over the O&W a quarter mile to the left, and then the Newburgh branch passes over the O&W another mile beyond that. Into the 1960s, the Erie employee timetable warned train crews about the height clearance for this bridge. (Ray Kelly.)

Four

THE NEWBURGH BRANCH

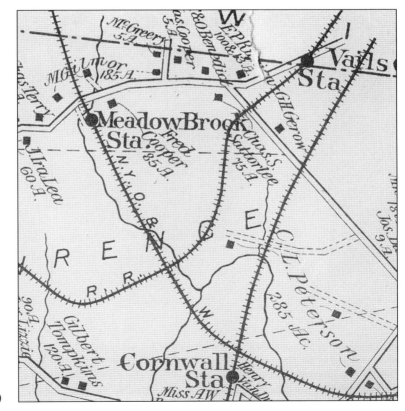

This is where the two branches leave the junction at Vails Gate and cross over the O&W. The Newburgh branch heads into an elevated curve outside of Vails Gate to go over the O&W main line and then continues towards Salisbury Mills. The current site of the Meadowbrook station is a mile west of the branch along Route 94. (Author's collection.)

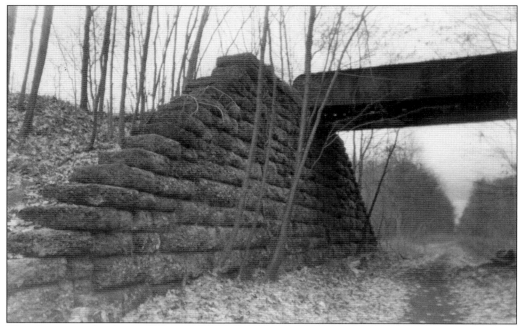

The abutments for the bridge over the O&W were built for two tracks, but the second track on the branch never reached this far. The O&W was building through in the 1880s at the same time the Erie was double-tracking its line from Newburgh to Vails Gate. The bridge here was built for two tracks just in case. (Author's collection.)

The branch's bridge over Jackson Avenue is seen here in the summer of 1985. The timetables list this as a flag stop under "Bethlehem Bridge crossing" at milepost 10.4. On the abutment below, "Erie Railroad" was stenciled. The bridge and its abutments were taken down not long after this photograph was taken. (Author's collection.)

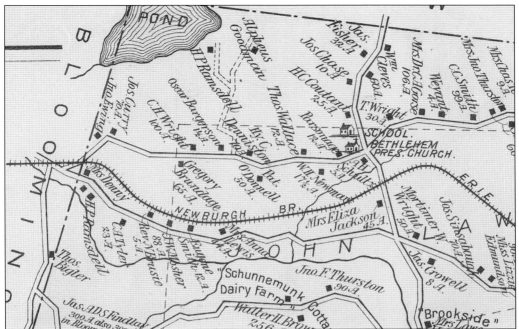

From the Jackson Avenue overpass, it is 11 miles to Greycourt. The Moodna Viaduct rises over the branch between mileposts 11 and 10. The Salisbury Mills station (below, center) is at milepost 9.4, just before the tracks cross Clove Road and head into the straightaway. Clove Road and its phone box are in the foreground. A stock house and cattle ramp once stood in the open area behind the station, which was known as the Rag House. When the paper mill was in operation, the "night haul" would set out cars here, and the woman who owned the general store nearby would stay open to serve the crew coffee or ice cream, depending on the time of year. (Both, author's collection.)

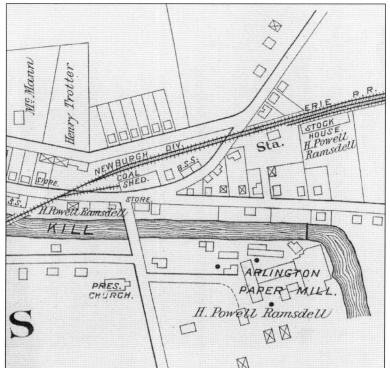

This is the station area around 1900, with the Arlington Paper Mills along Moodna Creek at the bottom of the map. The coal shed is in the center. Moodna Creek was still known at the time as Otter Kill. This more infamous name dates back to the Indian massacre of a family of settlers along the outlet of the creek at Cornwall. (Author's collection.)

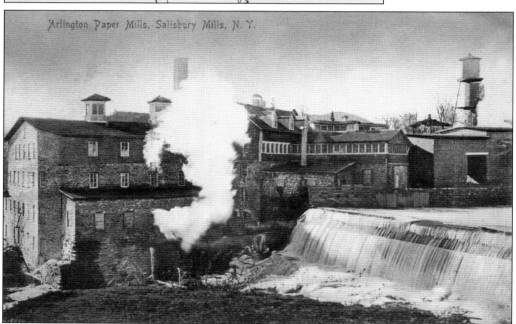

The Ramsdell family, whose influence had such a tremendous effect on the history of the Erie Railroad, was still very prevalent in Salisbury Mills around 1900. They were the owners of the Arlington Paper Mills, one of the biggest customers on the branch outside of Newburgh. The family also owned the stock house and other properties. (Author's collection.)

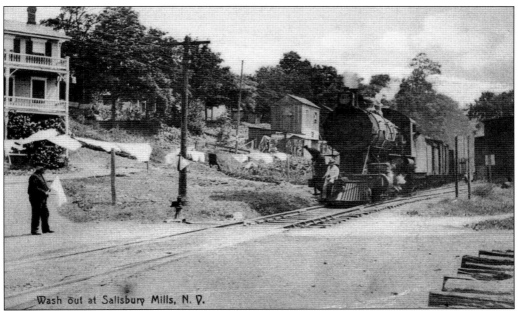

The unusual postcard above is titled "Wash out at Salisbury Mills." Why the washout would be so close to the tracks in the days of steam is a mystery. It is also strange that the man on the engine is dressed in white. Perhaps this card was created to promote the advantages of clean-burning anthracite coal. Erie's big competitor, the Lackawanna Railroad, made a legend out of its promotion of Phoebe Snow and its road of anthracite. The postcard below shows "Orange County's Busy Store," located next to the Orrs Mills grade crossing, as shown by the tracks at the extreme bottom left. The building still stands today. The railroad's coal shed was located along Orrs Mills Road, just to the right of this scene. The railroad bridge over Moodna Creek, just to the left of this, is the only thing left today to mark that a railroad ever went through here. (Above, Dennis Carpenter; below, author's collection.)

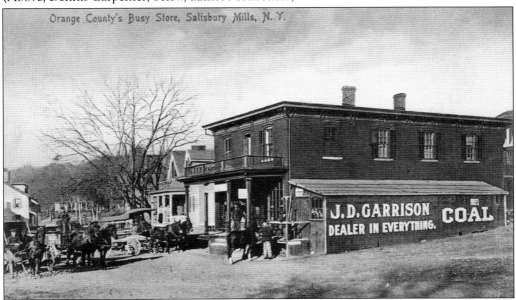

This photograph was taken in 1964 of the last coal hopper to ever use the coal shed ramp. The shed that once covered it was long gone by the time of the photograph. The Arlington Paper Mills changed hands at least once over the years, and after they closed in the 1960s, this ramp was of little use. (Dennis Carpenter.)

Central Railroad of New Jersey (CNJ) engine 1520 and its caboose work the branch at the site of the coal shed. Also known as the Jersey Central, this was one of the lines taken over by Conrail in 1976, dating this image to the last years of service on the branch. In 1867, "Commodore" Vanderbilt of the New York Central had failed in an attempt to gain control of the Erie. The formation of Conrail, more than 100 years later, finally brought them together. (Russell Hallock.)

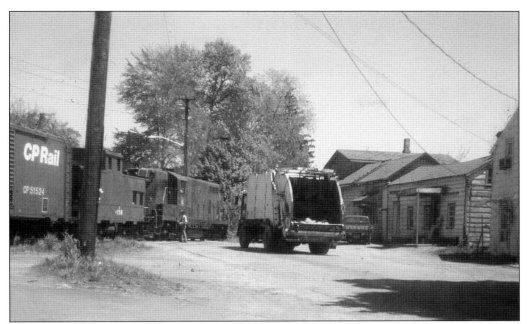

CNJ engine 1520 crosses Clove Road. A sanitation truck waits for the train to pass, and a flagman guards the crossing. The building to the right of the engine and the truck was the original Salisbury Mills Post Office. It stood into the 1990s before being destroyed by a fire. (Russell Hallock.)

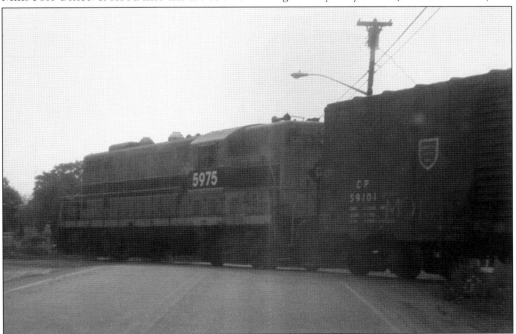

Here, an Erie Lackawanna engine crosses Orrs Mills Road. The engine has had its numbers redone to match Conrail numbering. Just to the left of the engine's pilot is the monument to the soldiers of the War of 1812 and the Civil War, which still stands today as one of the last surviving remnants of the old Salisbury Mills. (Russell Hallock.)

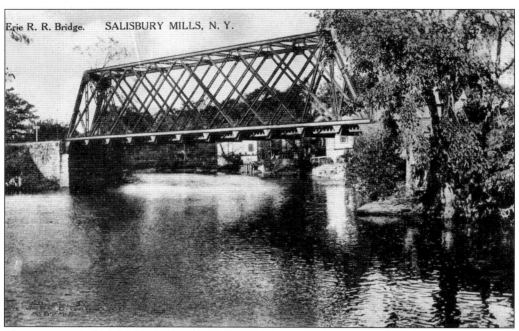

This is a postcard of the first of five bridges over Moodna Creek, just past the Orrs Mills crossing. At the left end of the bridge, images have been found with the words "Otterkill" stenciled on one side and the milepost designation 9.1 on the other. All of the bridges on the branch except for the Jackson Avenue Bridge still stand today. (Author's collection.)

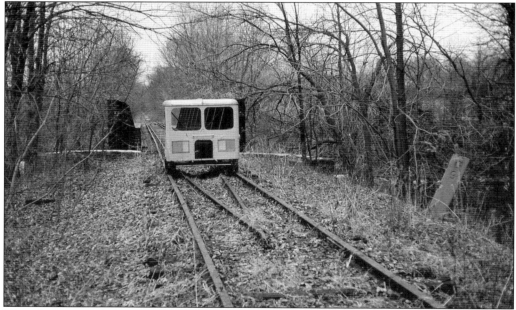

This photograph shows the second bridge in 1982. Service on the line had ended, and the rails were removed a year later. This is one of the motorcar trips Joyce Sternitzke and Russell Hallock took with a group of fellow railfans in the early 1980s. This section of roadbed has changed little over the years, save for some battering from Hurricane Irene. (Joyce Sternitzke.)

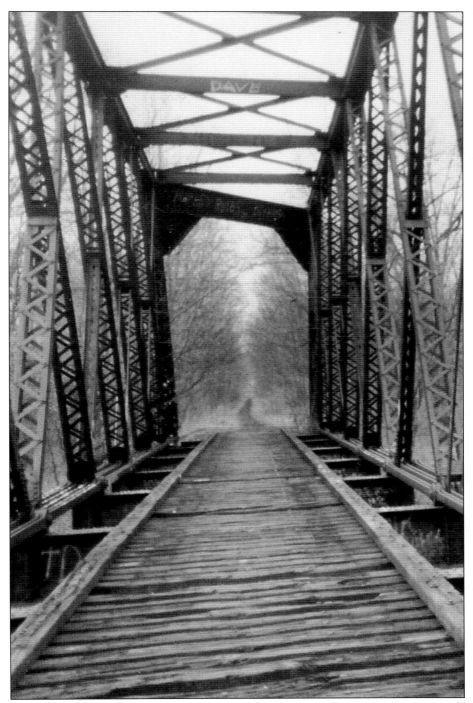

This pin truss bridge, between mileposts 8 and 7, dates back to 1871, when the Erie's rails were still six feet apart. The wide gauge was a mistake from the start, and the cost of converting the whole Erie system to standard gauge was yet another example of the Erie being in and out of financial trouble. (Author's collection.)

There was a walkway on one side of the tracks so crews could walk alongside the train and do switching for the passing siding. The switch was just east of the bridge. A plaque was once fixed to the top of the bridge with the date 1871 on it. Washingtonville historian Edward McLaughlin lived just across the creek from the bridge, and the whistle of the mail train would be his signal to start for school. There were two grade crossings east of the bridge and two west of the bridge. In Washingtonville, the whistle for the crossing at Blooming Grove could just be heard. (Both, author's collection.)

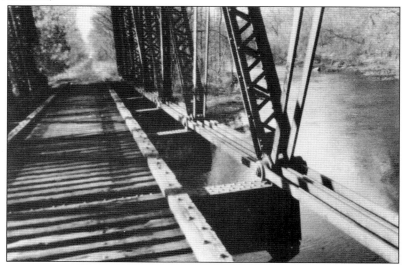

Washingtonville is seen here in 1903. The station and freight house were just over the tracks on Bridge Street (later Depot Street). Edward McLaughlin fondly recalled the railroad activity that once existed here, including the way freight coming from Newburgh would pause at the big, old wrought-iron truss bridge where the branch crossed. The head brakeman would throw the switch for the passing track, and the freight of sometimes 25 assorted cars would pull into the switch. There would be an hour or more of the constant shuffling of cars in and out of the Seacord & Cooper Brothers lumber, coal, and feed mill's house tracks. Then, more train movements were made at Frank Brown's coal and feed store, and perhaps a car of glass milk bottles or coal would be needed for the Borden's Creamery. There would then be two more daily trains, one eastbound and one westbound. (Author's collection.)

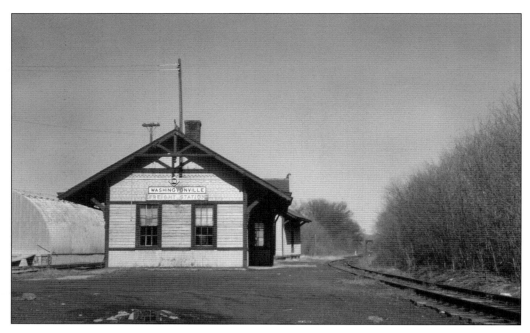

These are two different views of Washingtonville station. The photograph above was taken in 1964. The photograph below was taken in the 1920s or 1930s. Round-trip train fare on the branch from Washingtonville to Newburgh in the 1930s was 25¢. The semaphore signal would have come off not long after scheduled passenger service ended, relegating the branch to local freight service only. The station was purchased by Edward and Joan McLaughlin in the late 1960s and restored to be used as an antique store and bookshop. The building, which replaced one that was lost in an 1880s fire, stood into the 1990s. (Both, Dennis Carpenter.)

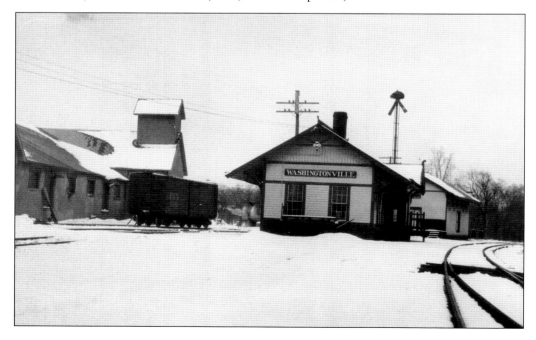

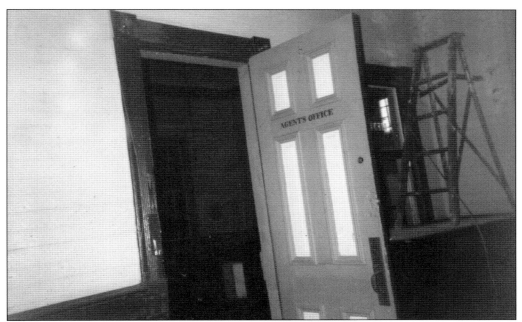

These two photographs, taken in 1991 by the author, show the inside of the station, with the agent's office (above) and the ticket desk (below). Edward Parks was the stationmaster at Washingtonville in the late 1920s. Washingtonville historian Edward McLaughlin recalled as a schoolboy watching Parks going through all of his duties, keeping track of the freight house deliveries as well as helping passengers purchase tickets and send out Western Union messages. He had to report the times of passing trains, and there was an open phone to listen to the dispatchers reporting trains on other lines. With all this, he still found time to chat with anyone who came to the depot. (Both, author's collection.)

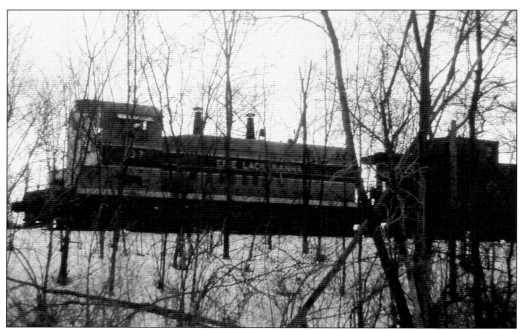

The image above shows the veteran engine 435 as it brings its train into Washingtonville on the long embankment west of town. Russell Hallock recorded the nostalgic scene below in December 1969 of engines 435 and 437 cutting their way through a snowstorm. The concrete base of the station can still be located, but a strip mall covers the yard site today. A historic marker by the Route 208 crossing marks the site of the railroad line. (Both, Russell Hallock.)

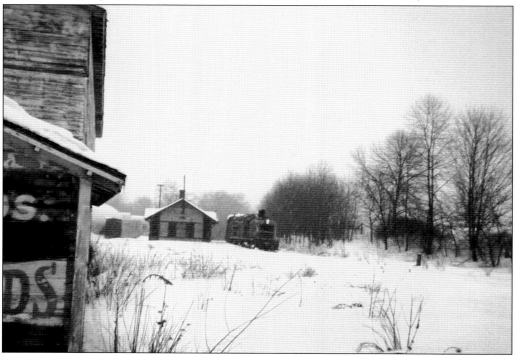

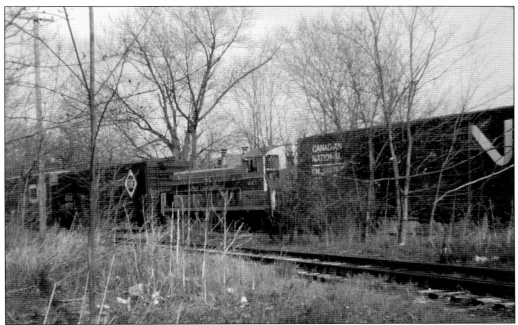

The photograph above shows the main line west of the station as the local goes through its switching chores. The photograph below was taken just west of the Route 208 crossing. The sign located on the 208 cross-buck points towards Depot Antiques, which dates the image to the 1970s when the McLaughlins operated their shop out of the station. The station was severely damaged in a fire in the early 1990s. Edward McLaughlin passed away in 1995. His wife, Joan, passed away in 2010. The faded sign for their antique store, which points from the direction of Depot Street, remains. (Both, Russell Hallock.)

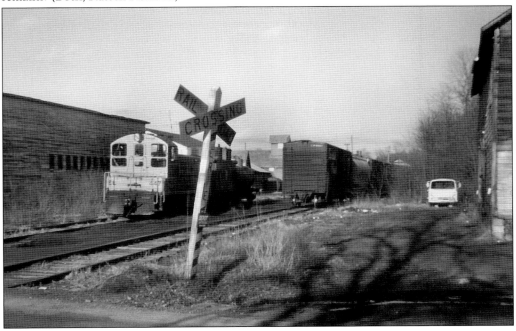

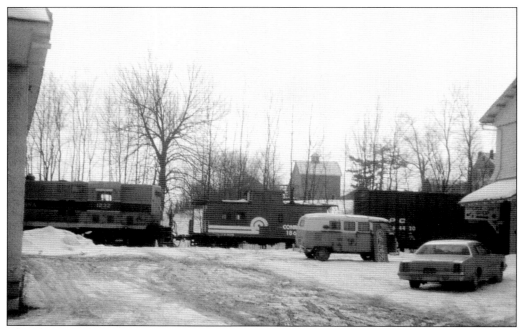

The photograph above was taken by Russell Hallock from the hill that overlooks the station. It shows Erie Lackawanna engine 71228 working the Washingtonville yard in February 1976. Below, looking towards the same hillside, Conrail engine 1232 rolls past the Washingtonville station. The sight of a Conrail train on the property means that only a year of railroad service remained. A total of 127 years of railroad service came to an end in 1977. The bottom floor of the building to the right served Washingtonville as a thrift shop before it disappeared into history. The building to the left still stands, but everything else is gone, replaced with a strip mall and memories. (Both, Russell Hallock.)

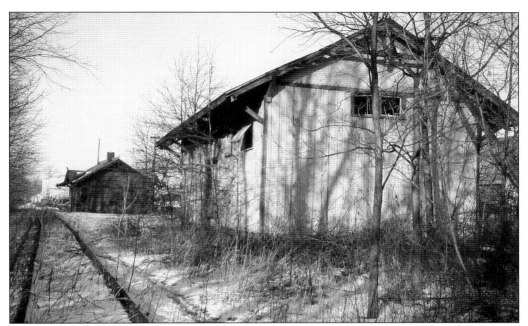

The station and freight house are seen above in 1981. When the author visited the site that summer, the freight house was almost invisible in the overgrowth. It was gone by 1985. In 1983, even as the rails were being pulled, Russell Hallock and a group of locals and businessmen were starting a grassroots campaign to preserve the line and restore it for tourist operations and possibly even local freight service. The rails were already removed on the Vails Gate end of the line. The tourist line would never come to be. Below, in 1985, the station, even under a blanket of snow, looks clean and dignified. (Above, Russell Hallock; below, author's collection.)

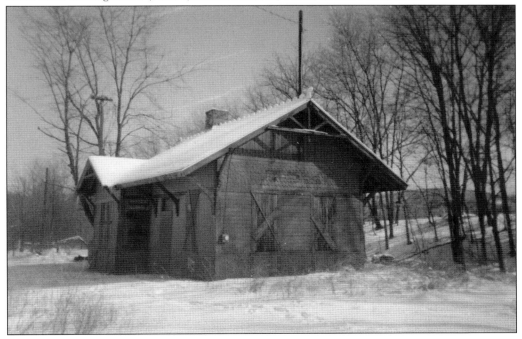

The grade crossing for Route 208 (Monroe Road) is seen above, and the crossing for Route 94 (Chester Road), on the east side of Washingtonville, is below. The rules governing grade crossings in the April 1961 employee timetable were the following: "Trains and engines will come to a full stop, not less than 75 feet or more than 125 feet from, and not exceeding 5 miles per hour, over the following crossings: Temple Hill, West of Vails Gate Junction; Blooming Grove Turnpike, east of Salisbury Mills; Monroe Road, first crossing east of Washingtonville; Chester Road, second crossing east of Washingtonville. No movement of cars will be made except when attached to an engine." (Both, Russell Hallock.)

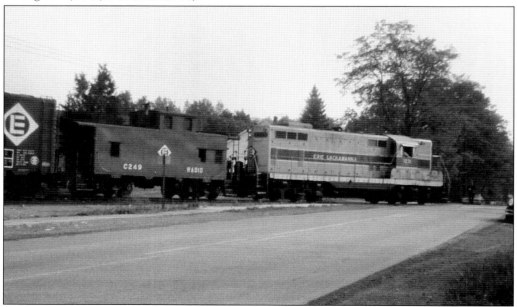

Just past the Route 208 crossing is the fourth Moodna Creek bridge (above). Beyond the bridge and near the Chester Road crossing stood Borden's Creamery (right). The building is still there today, minus the chimney. To switch milk cars out of the creamery and onto the eastbound train, the engine would uncouple from its train at the station. It would then pull the cars out of the creamery siding and push them up to the crossing. A brakeman would hold the cars with a handbrake. The engine would then reverse and switch back into the siding. The brakeman would release the brake enough so that the cars would roll down to the train. The engine would then come down, and the crew would couple up the train and head off towards Greycourt. The crew had only three minutes for the whole stop. (Both, author's collection.)

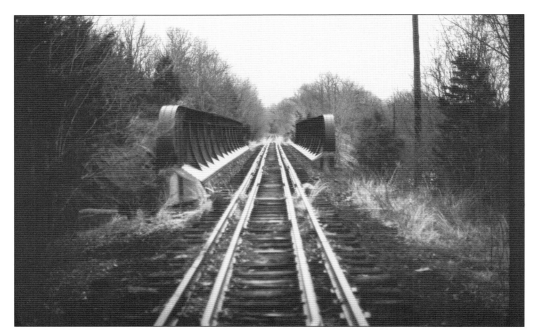

Between mileposts G4 and G3, the branch crosses over Route 94, three miles from Craigville. The photograph above was taken in the early 1980s, while the image below is from 1971. This bridge was built in 1940, and with its concrete deck it is one of the most solid structures on the whole branch. A half mile to the west, the tracks pass through Slate cut. To the east is Clark's cut, which is named for two ladies who once lived near the railroad in Craigville and would knit hats and scarves for the railroad crews. (Above, Joyce Sternitzke; below, Russell Hallock.)

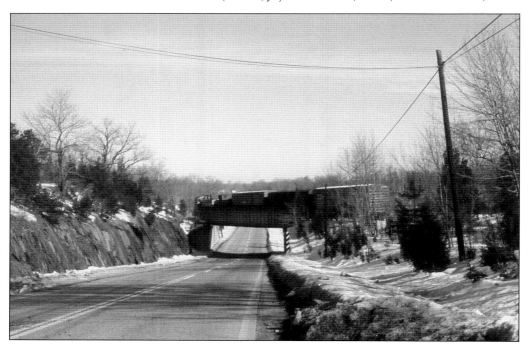

Five
Dennis Carpenter's Photographs

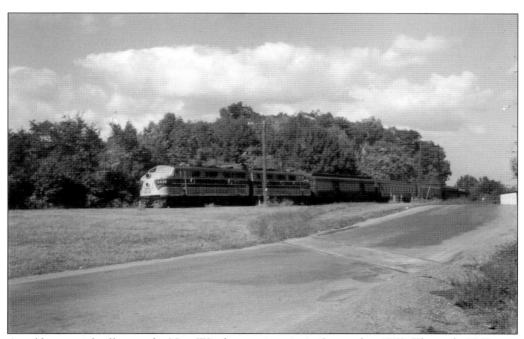

A railfan special rolls past the New Windsor station site in September 1963. The early 1960s saw a number of railfan trips over the Erie, the Lehigh & Hudson River, and the West Shore. The overgrown track that crosses Union Avenue in the center of the image once serviced a coal shed. The New Windsor station stood until the 1950s. (Dennis Carpenter.)

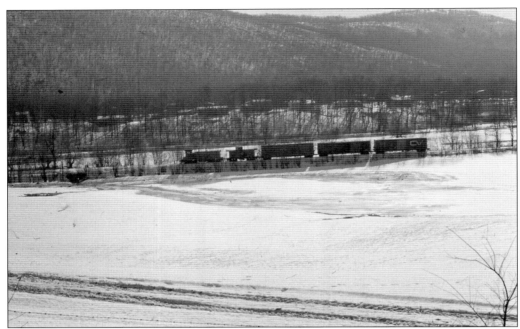

Above, a westbound freight rolls through a snowy landscape in Salisbury Mills. The length of the train tells of the decline in business on this end of the branch as the 1970s wore on. Below, vintage automobiles (left) and a fire truck (right) set the scene as this railfan special with Lackawanna colors rolls through Salisbury Mills and over the Orrs Mills grade crossing. As business waned and the track deteriorated, this grade crossing was one that drivers had to be wary of; it is one more of those things from the "good old days" that are looked back upon with an odd mix of exasperation and affection. (Both, Dennis Carpenter.)

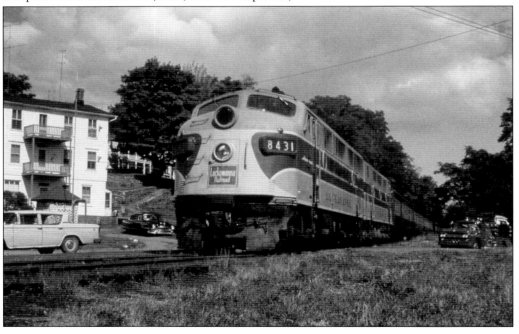

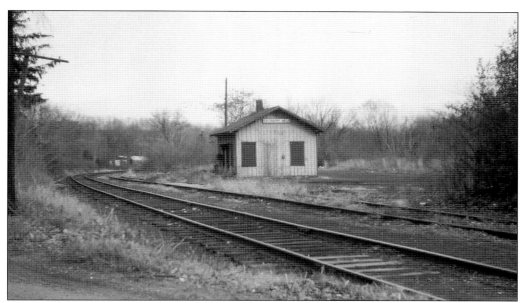

One of the two tracks seen above in front of the station is a passing siding. In the employee timetables, eastbound trains had clearance over westbound trains; however, by 1971, two trains passing each other here would have been a rare sight. The station was gone not long after these photographs were taken, and the set of double track in the Clove Road crossing, in the foreground, remained until the spring of 2013, a full 30 years after the last train left town. Up past the curve is milepost G10, and the roadbed passes through a deep cut in the hillside that keeps this section of the railroad flooded and largely unpassable. (Both, Dennis Carpenter.)

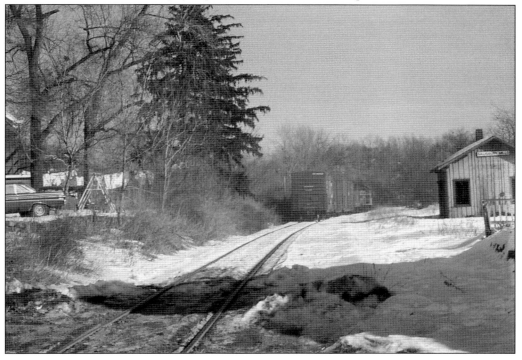

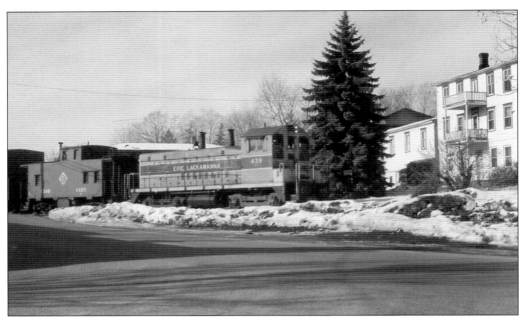

Newburgh Branch veteran engines 436, 437, and 439 were among the new fleet of diesels built for the Erie in 1952. They would survive into the Conrail years. The president's letter in the Erie's annual report for 1953 remarked, "The program of converting our motive power from steam to diesel covered an eight year period and cost $80 million dollars. It was the largest improvement program ever undertaken by your railroad and raised the Erie's physical capacity to the highest point in its history." In the image below, the sight of the 439 and its train passing directly behind the post office is a scene only an American country railroad line could offer. (Both, Dennis Carpenter.)

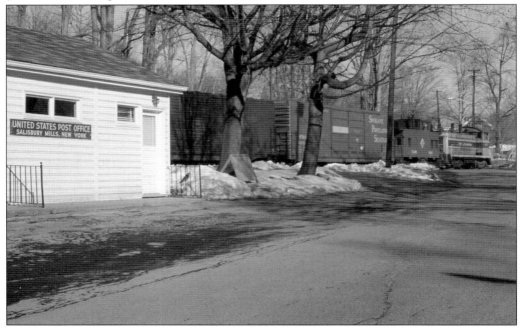

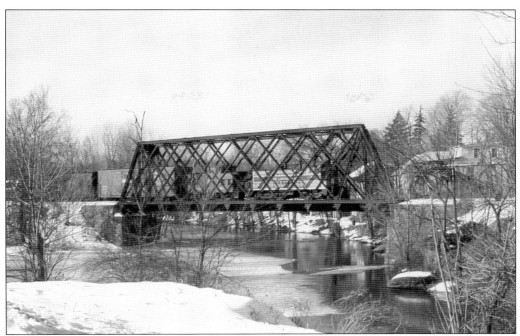

The Moodna Bridge is seen on this page, located just past Orrs Mills Road. In the photograph at right, a railfan special crosses the span in September of 1963. In early 1953, a 54-day a steel strike cost the Erie $6 million in lost revenues, and work was beginning on the interstate highway system. In the annual report for 1952, though, the president proudly stated, "We are well prepared to render an up to date, efficient, and dependable service to our customers and look forward with confidence to our ability to compete for any available traffic, now and into the years ahead". (Both, Dennis Carpenter.)

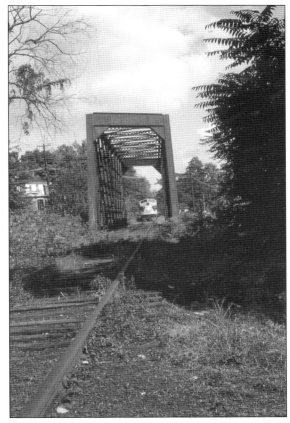

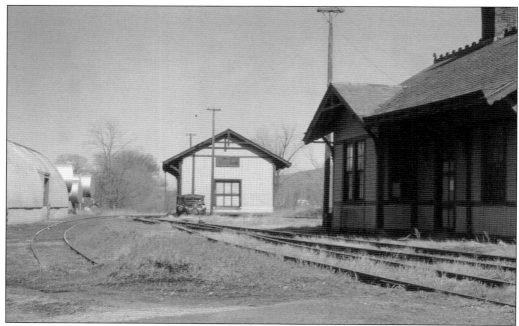

The Washingtonville station and freight house area still looked well maintained in 1964. (Can anyone identify the type of vehicle parked by the freight house?) Passenger service on the branch had been nonexistent for 30 years at that point, and *The Lake Cities* closed out regular passenger service on the Erie on January 5, 1970. It was a far fall from 1924, when the annual report showed passenger revenue exceeded $13 million over the Erie system, including its two Newburgh branches. One only has to look at the traffic that clogs the intersection of Routes 94 and 208 in Washingtonville to wonder what might have been. (Both, Dennis Carpenter.)

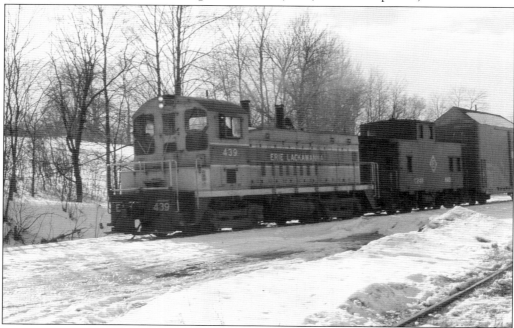

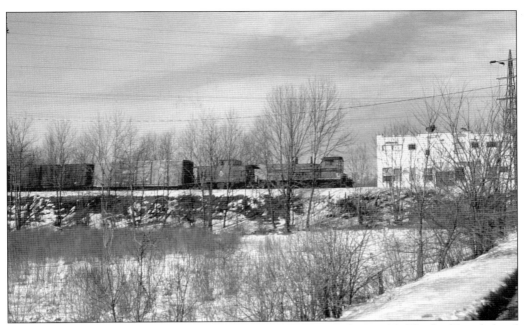

Seen here is Blooming Grove, just east of the station site, at milepost 4.8. The building behind the tracks is what remains of Sheffield Creamery. A historic marker along Route 94 in Blooming Grove marks Sears-Howell Farm, which was established 1791 and bred nationally known, award-winning Ayrshire cattle. In 1880, it was the first creamery to bottle milk on its farm for the New York City milk trade. (Dennis Carpenter.)

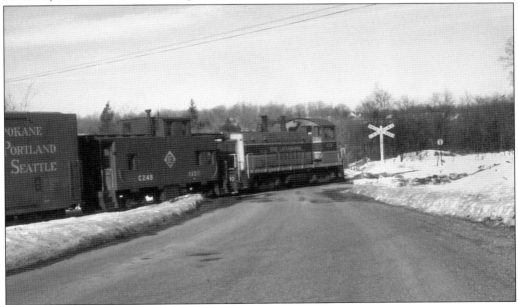

This is the Hardscrabble Road crossing. The Craigville station was to the right, at milepost 2.2. The Lehigh & Hudson River Railroad also had a station at Craigville. Like the Erie, it dropped passenger service in the 1930s. To the left is the last major rock cut on the line; from there, it is a straight run to the wye at Greycourt. (Dennis Carpenter.)

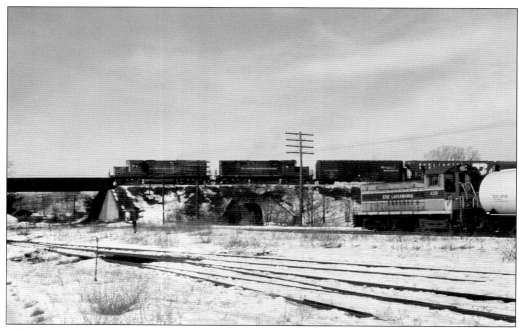

These two photographs show a Lehigh & Hudson River (L&HR) train passing overhead as the "drill" comes off the Newburgh branch. The west leg of the Greycourt wye was removed with the end of steam, as were the water tank and columns. Trains that came off the branch would work out of "DW" yard in Middletown. "DW" were the telegraph call letters for the Erie's Middletown yard. After service to Greycourt ended, trains for what was now the Newburgh spur would work out of Kingston. The L&HR is now operated by the Susquehanna Railroad, and the Erie main line is now the Orange County Heritage Trail. (Both, Dennis Carpenter.)

Six
Penn Central and Conrail

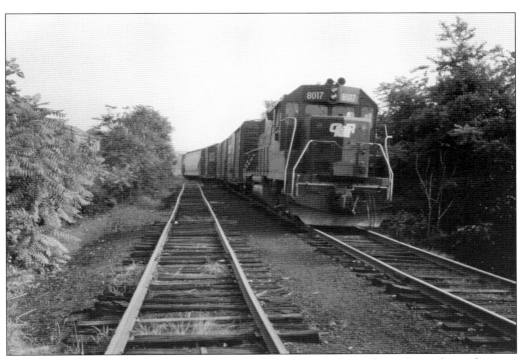

The merger of the Pennsylvania Railroad and the New York Central into Penn Central was in trouble from the start, as a vicious circle of delays caused by derailments drove more business to trucks. A lack of business then caused deferred maintenance and deteriorating trackage. This image shows a derailment at Vails Gate switch, with the Penn Central logo barely hidden by the Conrail logo. (Russell Hallock.)

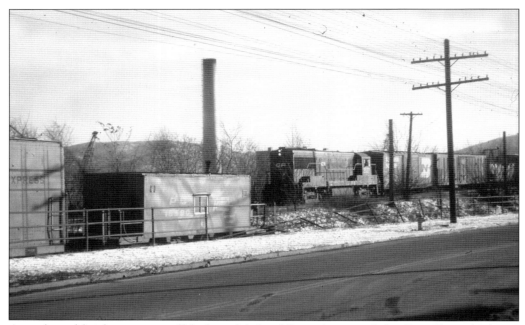

A westbound freight is coming off the branch behind Conrail power, while a Penn Central caboose brings up the rear on the West Shore Line. These unusual-looking cabooses were built out of old boxcars, and the 18590 seen here was one of 75 built in 1967. It survived to wear Conrail blue. (Russell Hallock.)

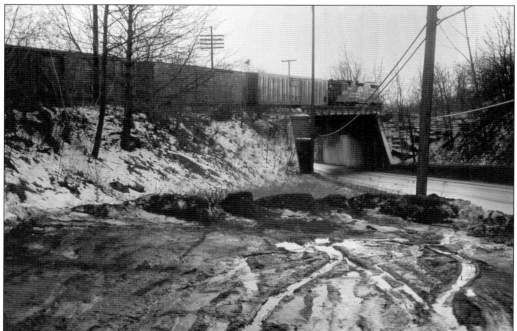

A Conrail train crosses over Water Street and digs in for the stiff climb to Vails Gate. The removal of the West Shore's tunnel in the 1980s led to the entire embankment to the left of the bridge being taken out. It was replaced with steel bridgework. (Russell Hallock.)

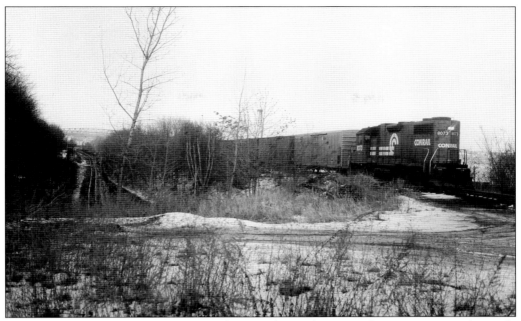

This photograph looks from the top of the tunnel as GP38-2 0873 brings a train up the grade leaving Newburgh. Conrail inherited 223 GP38-2s from the Penn Central. Conrail also purchased 115 brand-new GP38-2s in 1978–1979. The four-axle units churned out 2,000 horsepower and were regulars in all types of service. (Russell Hallock.)

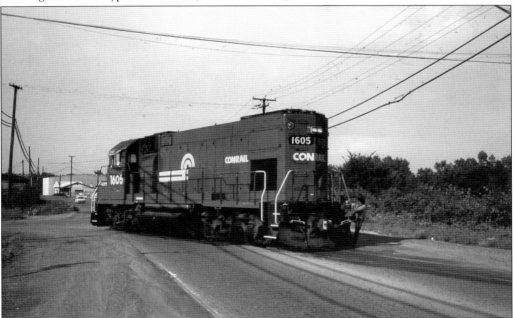

Conrail 1605 crosses Lake Street (Route 32) on the Newburgh industrial spur. Miron Lumber, the last customer on the spur, is off to the left. Conrail's fleet of 100 of these lightweight road switchers arrived numbered in the 1600 series in 1979. They were purchased for light road switching and local service. (Russell Hallock.)

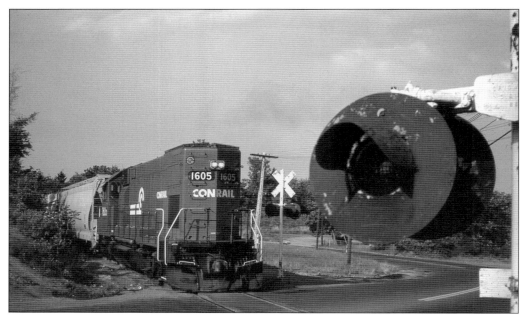

Conrail 1605 is seen here crossing Union Avenue in New Windsor. The spur's tracks were looking worse for wear in the early 1980s before a complete upgrade was done. Today, the spur is maintained, and a scrap dealer keeps the spur in operation in New Windsor. But, east of Newburgh, the spur awaits new life. (Russell Hallock.)

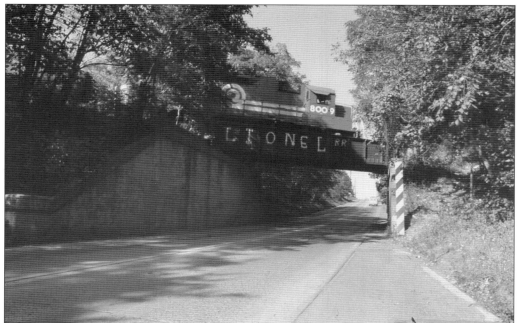

Engine 8009 crosses the "Lionel bridge" over Route 32. This bridge was built in the 1920s. GP38-2 8009 was delivered to the Penn Central in July 1972 as part of an order for 100 units. All 100 of them then went to the Union Pacific, and the 8009 was retired in June 2003 as Union Pacific 445. (Russell Hallock.)

Above, Erie Lackawanna colors are still working at the Tarkett plant in February 1976. After April 1 of that year, Conrail blue started to become a common sight on the spur. Below, caboose 21238 crosses Route 94. Erie operating rules required a flagman to protect the highway crossings where there were no flashers. The N21 was the only type of caboose bought new by Conrail, with a total of 113 cars in the series 21201–21313. As the 1980s word on, the End of Train Device (ETD) and its now-familiar flashing light on the rear of the train took the place of the rear train crew for monitoring train operations. The caboose receded into fond memories. (Both, Russell Hallock.)

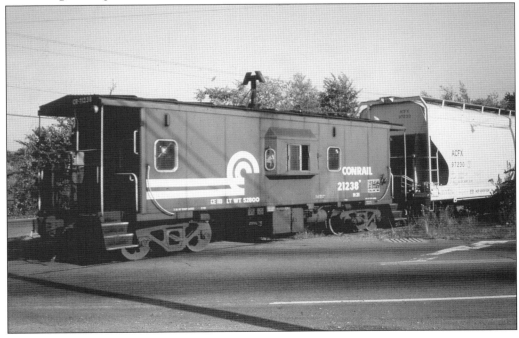

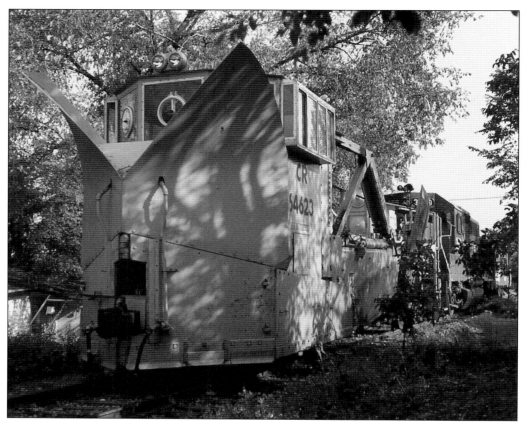

Above, Conrail engine 3159 and snowplow 6423 are in Vails Gate, just west of the Route 300 crossing. The leaves are still on the trees, but the presence of a plow means the snow season is on the way. Below, the end of the train crosses over the second of the two sets of double bridges over Ceely Creek coming into Greycourt. The track to the right was a long passing siding and was used as a "mud switch." In steam days, this was the west leg of the wye. In the pre-Greycourt days, the Erie's employee timetables called the wye East Junction and West Junction. (Both, Russell Hallock.)

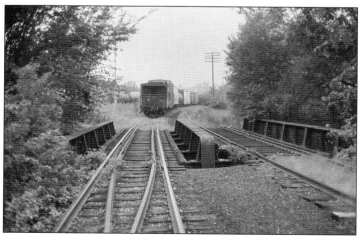

Above, the 437 performs switching duty in Washingtonville near the South Street (Route 208) crossing. In the 1920s and 1930s, Bob Barrett was the watchman for the grade crossing. Below, an eastbound freight crosses the second bridge over Moodna Creek in Salisbury Mills in February 1976. That year was a time of uncertainty for American railroading. The past decade had seen the railroading industry's darkest days. The next decade would see the first stages of its great comeback. But, in 1976, no one—from railroad employees to railroad shippers to trackside railroad supporters—seemed to know if this new government agency called Consolidated Railroad Corporation (Conrail) would be able to succeed. (Both, Russell Hallock.)

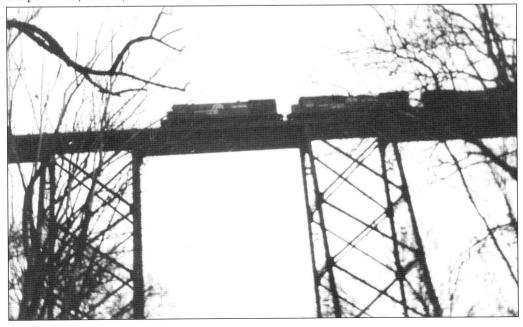

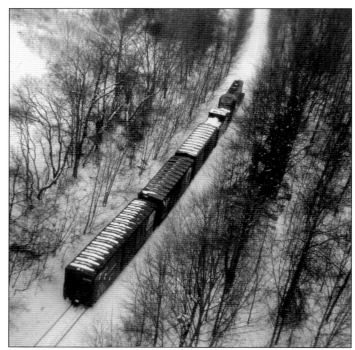

From the top of the Moodna Viaduct, Russell Hallock caught these two images of a westbound freight on the branch behind the Erie Lackawanna livery in March 1976. Hurricane Agnes had inflicted so much damage on some parts of the Erie that it drove it into bankruptcy, but the Erie was still the last to join the Conrail. Conrail chairman and CEO Edward G. Jordan reinforced the idea that Conrail would be a new railroad with new management. It would rise from the tangled mess of its bankrupt predecessors into what he called "a time for true rebuilding." (Both, Russell Hallock.)

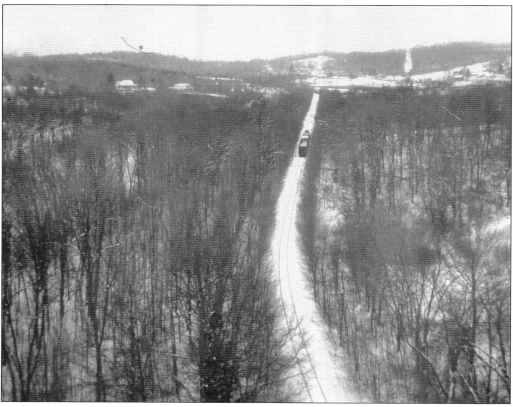

Seven
THE MOTORCAR TRIPS

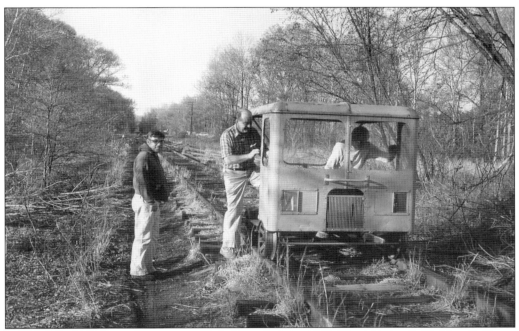

This is the motorcar and its crew at Vails Gate. In May 1983, Ward Poche (left), Harold Green (center), and Steve Sternitzke made their only trip to Vails Gate Junction. A homeowner put a road over the tracks just east of Salisbury Mills, which made it impossible to cover the whole section. (Joyce Sternitzke.)

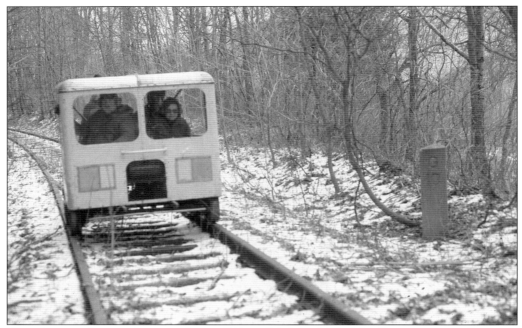

This photograph was taken at milepost G10 in Salisbury Mills. The *Enterprise* was a Fairmont Railway Motors M19F motorcar of Erie Railroad heritage from about 1951. The *Enterprise* had no motor, no windshield, and badly worn wheels, and critical parts of the belt drive were missing. But, by March 1981, all these issues had been addressed. (Joyce Sternitzke.)

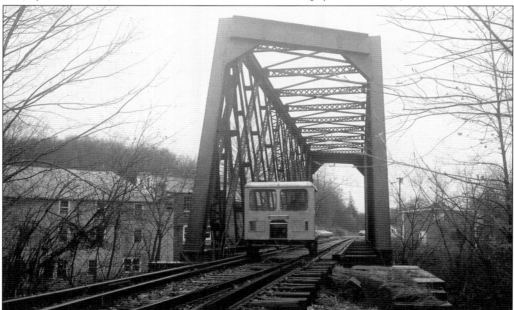

The motorcar is seen here on the bridge at Salisbury Mills. The Wisconsin motor that Russell Hallock found had a gear reduction gearbox, which at least allowed the *Enterprise* to run in a forward direction in operation. Unfortunately, an original Fairmont engine was not available, and it would be a few years before the motorcar members would actually see one. (Joyce Sternitzke.)

On April 21, 1981, the *Enterprise* made its first attempt at the branch setting at Washingtonville. Unfortunately, numerous mechanical issues cropped up, and the crew aborted going any farther. (Joyce Sternitzke.)

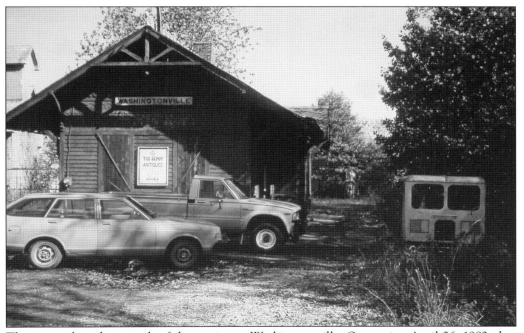

This is another photograph of the station at Washingtonville. On a rainy April 26, 1982, day, Russell Hallock and Joyce Sternitzke made another attempt over the branch. All went well this trip, and they made it to Salisbury Mills before reversing direction and making it all the way back to Greycourt. (Joyce Sternitzke.)

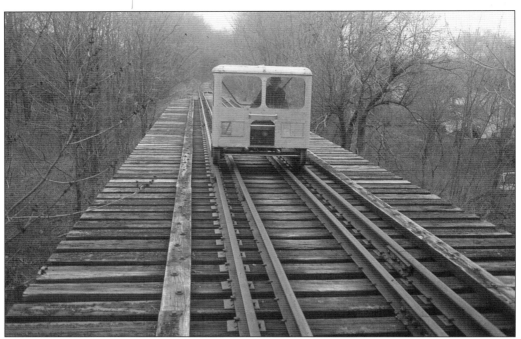

This is the fifth bridge over Moodna Creek. This crossing was called "Tin Bridge" because the original wooden trestle was clad in metal for fireproofing. Tin Bridge is one of the largest bridges on the entire branch, along with the Route 94 overpass and the bridge over Quassaick Creek in Newburgh. (Joyce Sternitzke.)

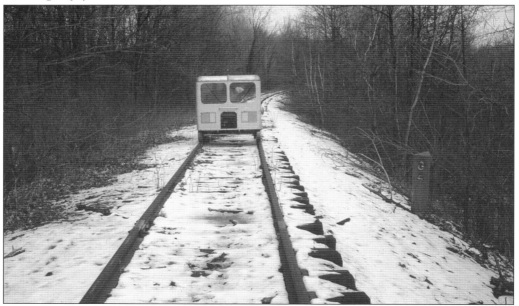

This image was captured at milepost G4, just outside of Craigville. The crew on the nine trips that were made between 1981 and 1984 included Russ Hallock, Fred C. Freer, Harold Green, Ken Green, the Sternitzke family, Lou Boselli, Jim Parella, Stan Roach, Edward J. McLaughlin, Russ Beggs, Jeff Hurst, Ken Kurdt, and Lloyd James. (Joyce Sternitzke.)

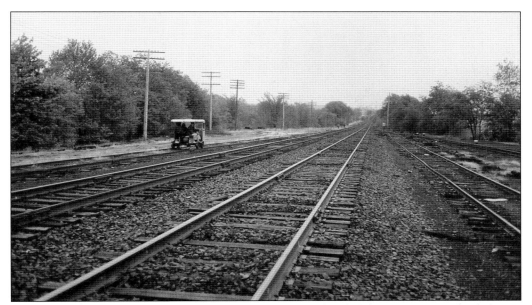

The Newburgh branch, now out of service, swings off just ahead of the motorcar. In the distance, the main line starts to climb the Oxford grade. In 1983, there were two more trips on the branch. Unfortunately, time was running out, and in December the scrapper began ripping up the tracks. On January 7, 1984, the *Enterprise* and its crew made the final trip ever taken on the Erie Railroad's Newburgh branch. (Joyce Sternitzke.)

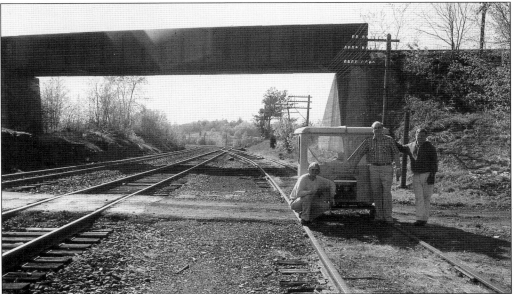

This photograph was taken at Greycourt. Standing with the motorcar are, from left to right, Steve Sternitzke, Harold Green, and Ward Poche. In the late fall of 1983, the scrapper began its work at Vails Gate and worked its way west. By New Year's Day, it had made it to just east of Salisbury Mills. There was no rail train, just a bulldozer and a dump truck with a small boom. The rail was ripped off the crossties, cut up into short pieces, and placed in the dump truck, with its final destination unknown. (Joyce Sternitzke.)

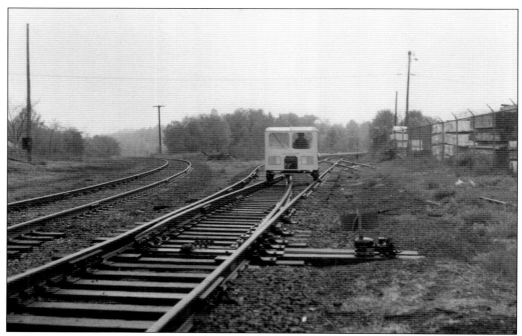

Maybrook yard is seen above, with the Lehigh & Hudson River line coming in from the left and the Erie on the right. In the background of the image below is what remained of the Maybrook roundhouse in the last years. The New Haven line to Maybrook, as well as Maybrook yard itself, was also scrapped under Conrail. Today, the facilities for the trucking terminal Yellow Freight occupy the site of the roundhouse. The facilities were built on the site of one rail yard out of the six that once made up Maybrook yard. (Both, Joyce Sternitzke.)

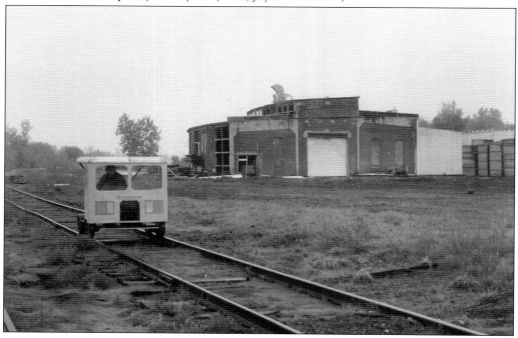

Eight
DECLINE AND AFTERMATH

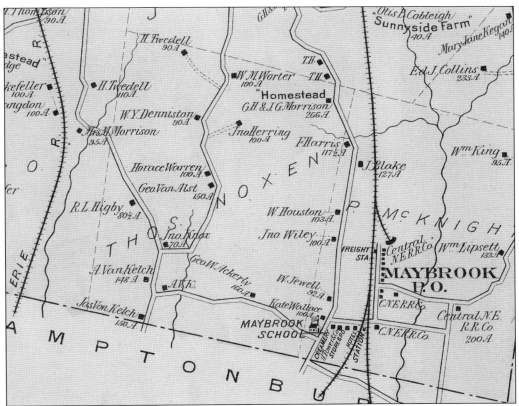

This 1903 map shows the beginnings of Maybrook yard on the right, marked by the freight house and the engine house, along with the junction of the Lehigh & Hudson River Railroad and the Central New England Railroad. To the left is the Erie's Montgomery branch. (Maybrook Railroad Museum.)

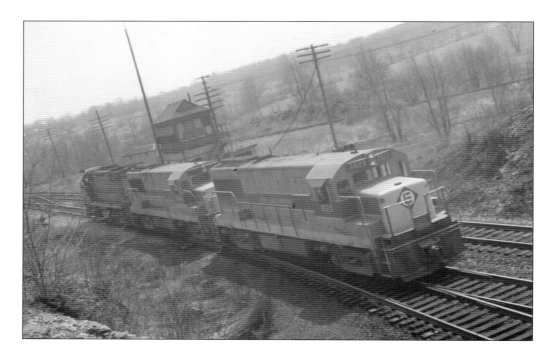

These images show Erie Lackawanna eastbound power (2411-2504-2523) drifting west on the loop track light from Maybrook, then east to MQ Tower. It went through the crossovers to the eastbound main and then onto their train. The 2411 later became Conrail engine 2485. The 2504 was built in September 1964. (Both, Maybrook Railroad Museum.)

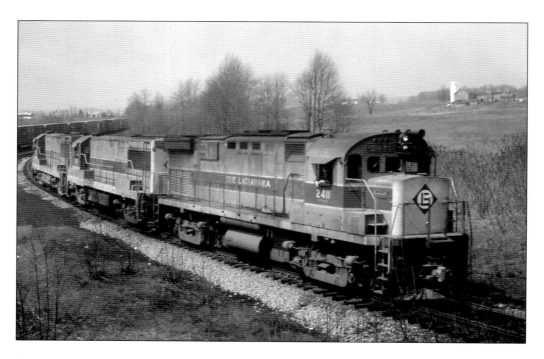

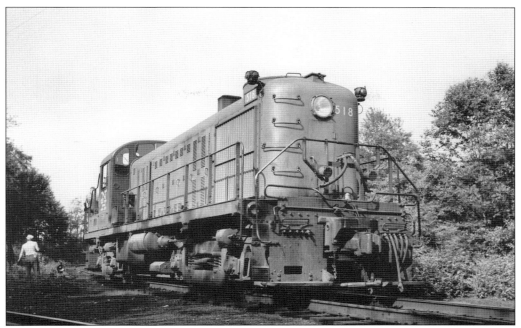

New York, New Haven & Hartford engine 518 does switching duty at Campbell Hall in June 1961. In the 1960s, four railroads still came through or connected at Campbell Hall, including the New York Central Railroad's Wallkill Valley line out of Kingston. (Maybrook Railroad Museum.)

The Strates circus train is seen here in Maybrook on June 8, 1961. The circus's animals were watered and exercised here. Many Maybrook citizens who grew up in the 1950s and 1960s have fond childhood memories of the annual circus trains coming to town via the railroad. The circus was a boon to local businesses when it arrived. (Maybrook Railroad Museum.)

Photographer John Stellwagen caught this Lehigh & Hudson River train in Maybrook in June 1963. The Lehigh & New England Railroad closed in 1961, and the New York, Ontario & Western closed in 1957. The vegetation on and around the tracks shows the decline of activity in the yard. (Maybrook Railroad Museum.)

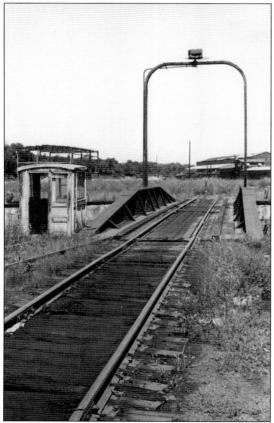

With the end of steam engines in Maybrook in the 1950s, there was less and less need for the turntable. And, judging by the condition of the turntable operator's booth, the table had not been used for some time when this photograph was taken in 1968. (Maybrook Railroad Museum.)

In these two photographs, the caboose at the end of these two vintage New Haven passenger cars suggests that the two veterans are spending their later years in maintenance-of-way service. The car shop is in the background in the image below. Regular passenger service to Maybrook ended in the 1920s, but in the years before World War I, passenger trains ran through here, destined north for Boston and south to Washington, DC. A completely separate set of tracks was used to detour passenger trains around the busy yard. A train called the "scoot" ran between Poughkeepsie to bring employees to and from work. The Maybrook station still stands and is now a private residence. (Both, Maybrook Railroad Museum.)

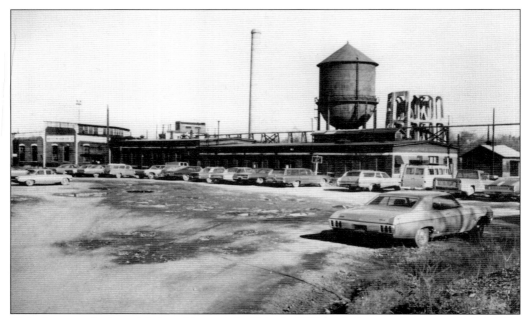

This photograph shows Maybrook's repair facilities in 1971, with the roundhouse to the left. The base for the water tower remains to the right, but the wooden tank is gone. Even at this late date, the number of cars parked outside the shop gives some indication of how many people the yard still employed. The Erie Lackawanna was the next railroad to declare bankruptcy, in 1972, after having to repair flood damage from Hurricane Agnes. (Maybrook Railroad Museum.)

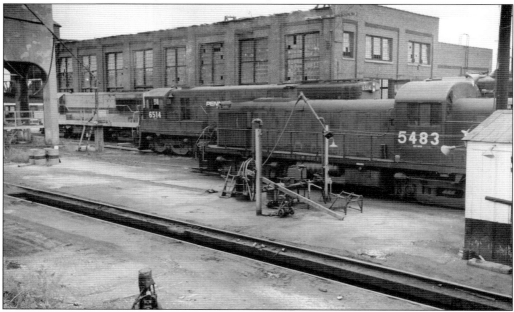

An Erie Lackawanna engine and two Penn Central engines occupy much of the track area outside the Maybrook shops in 1971. In June 1970, Penn Central declared bankruptcy; it was the largest corporate bankruptcy in US history at that time. The Erie Lackawanna followed suit in 1972. (Maybrook Railroad Museum.)

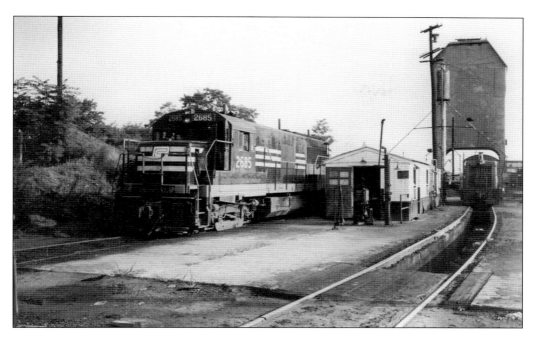

Above, a New Haven engine, now wearing the Penn Central logo, pauses alongside an unidentified engine at Maybrook's coaling and sanding facilities. Penn Central engine 2685 is now preserved and restored as New Haven 2525 in the Railroad Museum of New England. The Yellow Freight trucking terminal occupies this site in Maybrook today. Below, a string of New Haven power is spotted outside the Whiting Hoist shop. Whiting Hoist was lifting the engines off the ground for servicing. The Whiting Hoist Company is still in business today. (Both, Maybrook Railroad Museum.)

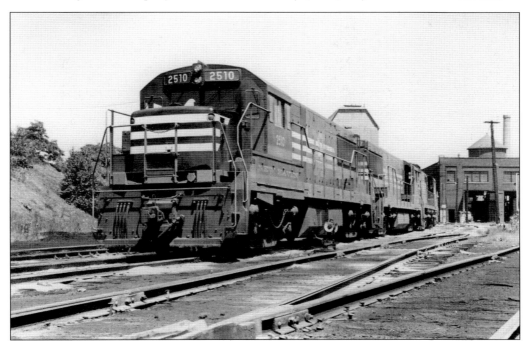

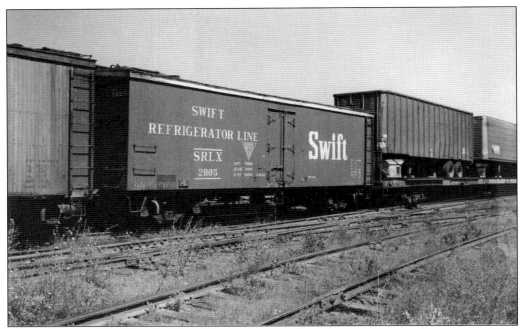

In 1878, Chicago meat packer Gustavus Swift hired engineer Andrew Chase to design a ventilated car that was well insulated and that positioned the ice in a compartment at the top of the car, allowing the chilled air to flow naturally downward. The meat was packed tightly at the bottom of the car to keep the center of gravity low and to prevent the cargo from shifting. (Maybrook Railroad Museum.)

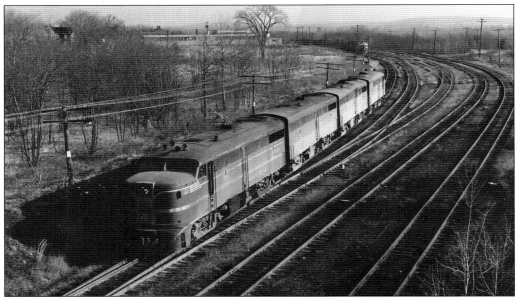

A New haven crew is backing down to its train in November 1960. By this point in time, plans for the construction of interstate highway I-84 are underway, with a bridge passing over the New Haven Railroad about a mile ahead of this train. The highway's completion spelled doom for the New Haven's Poughkeepsie Bridge route. (Maybrook Railroad Museum.)

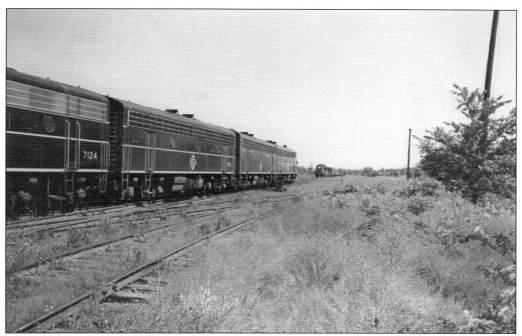

The date on this photograph is August 11, 1963. Erie train 98 is coming into Maybrook receiving yard and heading down track 13 to the no. 2 icehouse. In the distance, a Lehigh & Hudson River train is ready to depart. Barely seen in the far center distance are the smokestack for the powerhouse and the steel water tank. (Maybrook Railroad Museum.)

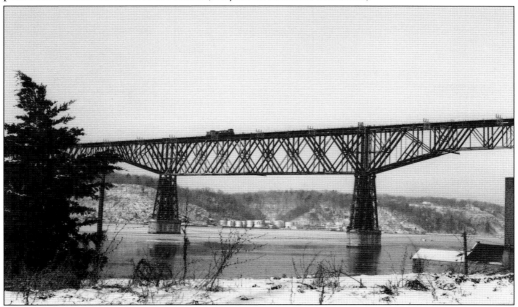

A Hew Haven engine and caboose cross the Poughkeepsie Railroad Bridge in January 1972. On May 4, 1974, the last train crossed the bridge eastbound behind five Erie Lackawanna units. Once the last car crossed, the bridge fell silent for over 30 years until its celebrated rebirth as a public walkway in October 2009. (Maybrook Railroad Museum.)

Thaddeus Selleck was appointed agent of the Erie at Chester, thus becoming one of the two original station agents, the other being John A. Bailey at Goshen. The excellence of Orange County's milk attracted stationmaster Selleck's attention early on. He was a practical man, and he suggested to farmers that they sell their milk to the New York City market as soon as the railroad was complete. At the time, the main milk supply in New York came from cows kept at brewery and distillery stables, feeding on brewery and distillery refuse. Below is the "High Bridge" over the Erie, just west of the station. This is today's Route 94, and the bridge was replaced in 1940. (Both, author's collection.)

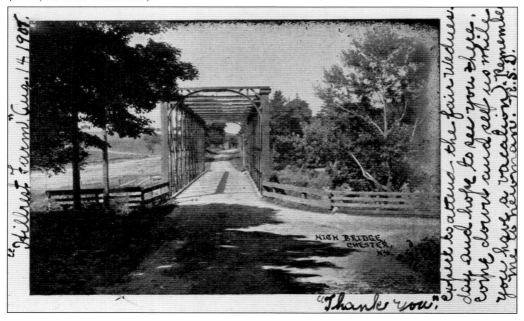

The 1991 image above shows the Greycourt station site on the left. The main line past either end of this spur had been out for eight years. The empty roadbed to the right is now the Orange County Heritage Trail. The photograph below looks east near the timetables at the far end of the Greycourt spur. The bridge to the left is the Heritage Trail, and the other two have been taken over by nature. This was the start of the stiff climb up the Oxford grade, which tops off about a mile west of Monroe. This was yet another one of the pusher grades on the main line that, in steam days, influenced the Erie's decision to construct the low-grade Graham Line. (Both, author's collection.)

Seen above is the main line roadbed looking towards Greycourt. The Lehigh & Hudson River bridge over the Erie is in the distance. Milepost 53 (to Jersey City) is to the right in the center of the wye that once connected the main line with the Newburgh branch. Below is one of the two pairs of bridges at the start of the Newburgh branch. (Both, author's collection.)

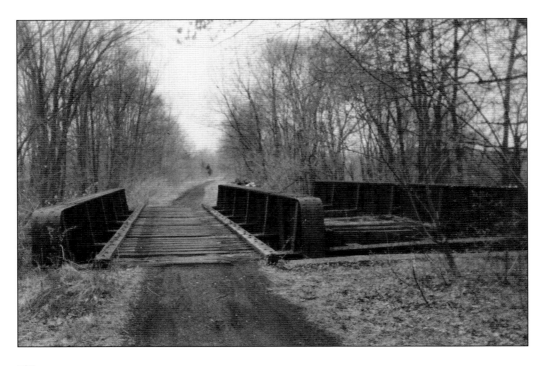

Above, the west leg of the wye is going off to the right. A few yards up from where the switch would have been, there is an old boxcar door that seems to have been placed there to cover an opening, possibly the connection for a water column to service steam engines. A water tank once stood in the wye near the creek. The image below shows a stone culvert under the main line east of Greycourt. (Both, author's collection.)

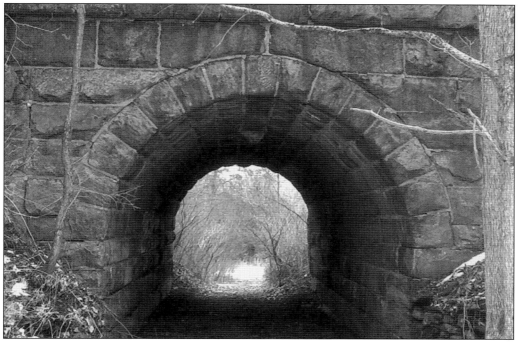

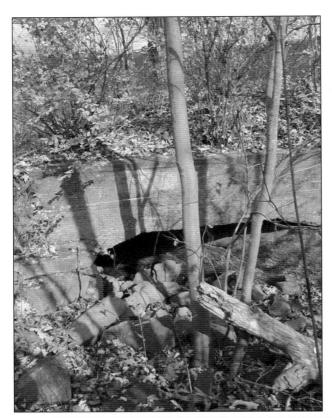

Below Monroe, along the main line, the concrete culvert (at left) was part of a spur that served the Mountain Lake Ice Company. In the days before mechanical refrigeration, cutting ice was an important industry. Ice that was a foot or more in thickness would be cut with large saws into strips and then cut into blocks to be stored in icehouses and used throughout the year. Below Craigville is Slate cut (below), one of the larger cuts on the Newburgh branch. In the days before dynamite blasting, rock cuts involved an iron drill and a sledgehammer to drive the pole into the rock. Once the hole was drilled, black powder was placed in the hole and ignited. It was a very labor-intensive and dangerous way of cutting out rock cuts and tunnels. (Both, author's collection.)

The Newburgh branch is seen above looking from the third bridge over Moodna Creek in the direction of Washingtonville. This section once held two tracks, one being a passing siding. The Washingtonville station is in the far distance, and a whistle post is to the right. Both are now long gone. The bridge is seen below. The branch was a single-track line, and, in the days of block-signal operation, the stations and towers that used them were Greycourt, Washingtonville, Salisbury Mills, and Vails Gate Junction. Greycourt and Vails Gate Junction were open from 6:00 a.m. to 8:00 p.m., and Salisbury Mills and Washingtonville were open from 8:00 a.m. to 5:00 p.m. When Washingtonville and Salisbury Mills were closed, Vails Gate blocked with Greycourt. (Both, author's collection.)

Above is a signal mast that still stands along the Heritage Trail west of Greycourt. Only when the leaves have fallen can this post be easily spotted. Below is the Erie main line west of Harriman as it appeared in 1991. With the removal of the Erie main line, a spur was left through Harriman to serve the Nepera Chemical Company. The trackage in this image was removed when the spur was cut farther back. The old wye and spur at Harriman were put back into use as commuter equipment storage when Hurricane Irene knocked out service on the Graham Line for several months. (Both, author's collection.)

Nine
ODDS AND ENDS

This edition of *Summer Homes and Rambles along the Erie Railroad* was published in 1888 to advertise to the traveling public the history and natural beauty of the areas in which the Erie passed through, as well as the locations of station stops. (Library of Congress.)

63
ON THE NEWBURGH BRANCH.

West of the Schunemunk Mountains is the romantic valley of the Murderer's Kill, through which the branch of the Erie Railway extending from Greycourt to Newburgh passes. The valley, like this entire section of Orange County, is full of historical associations. The Newburgh Branch and the Short Cut unite at Vail's Gate, six miles from Newburgh. It was at the former place that Generals St. Clair and Gates were quartered when the army was encamped in the vicinity. The Edmoston House, their headquarters, is still standing. It was built in 1755. At Washington Square, two miles from Vail's Gate, General Clinton had his headquarters in the Falls House, still intact. An ancient Indian burying-ground, and a number of very old churches are in the vicinity. Pickerel, bass, and perch fishing in the adjacent lakes. Livery at all the stations.

The areas that the Erie's Newburgh branches passed through were already rich in American history in 1888, when the nation's centennial had just been celebrated a decade before. In the late 1800s, boardinghouses and hotels advertised fresh mountain air and good trout streams, and livery stables were provided at all railroad stations. (Library of Congress.)

In Monroe, the old Erie main line is being cleared, and the Heritage Trail is being extended east. This photograph shows the overpass on Spring Street. The station that burned down in the 1970s was located just beyond the concrete wall to the left. The original Monroe station still stands along the roadbed a few hundred yards up and now serves as a local business. (Author's collection.)

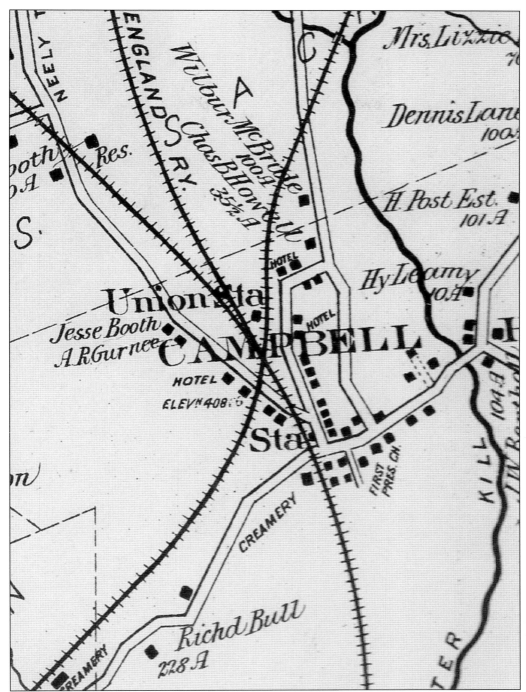

The junction at Campbell Hall is seen here in the years before the Graham Line was built through it. Clockwise from the left are Erie's Montgomery branch; the Central New England (CNE); the New York, Ontario & Western Railway; and the Lehigh & Hudson River Railroad, connecting with the CNE. (Author's collection.)

These two photographs show the remains of the Erie Railroad's Montgomery branch. The image above is the former crossing for Route 207 coming into Goshen. The one below looks towards the roadbed that is now covered by the entrance to the Metro North commuter station in Campbell Hall. This rail could still be seen sticking out from under the pavement in 1991. The commuter lot now covers the site of MQ Tower, but the connection off the Graham Line to Maybrook still serves several businesses in Maybrook, and the spur off the Montgomery branch that was once the Wallkill Valley Railroad brings service into Walden. (Both, author's collection.)

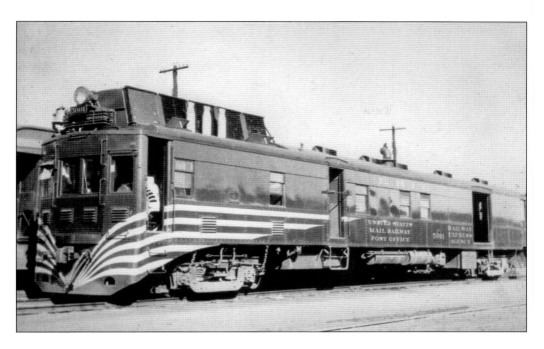

Motorcar 5001 (above) was typical of the gas-powered equipment that the Erie started to use as an answer to the growing competition from automobiles. The box-like pilot on the front end replaced the older cowcatcher-style pilots between 1938 and 1941, dating this image to the years after the Newburgh branch dropped passenger service. Below is an envelope with the Houghton Farm stamp that is dated 1883. Mail contracts were a major source of income for all railroads, including the Erie. The loss of those contracts was the final blow for many faltering railroad lines, including the shortcut. (Both, author's collection.)

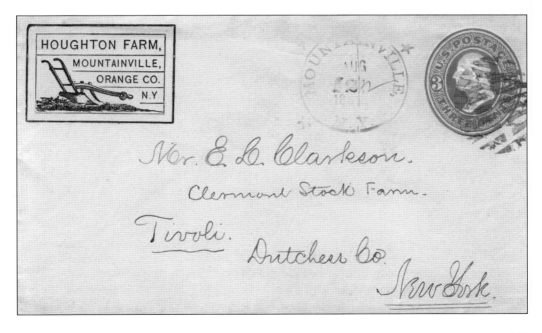

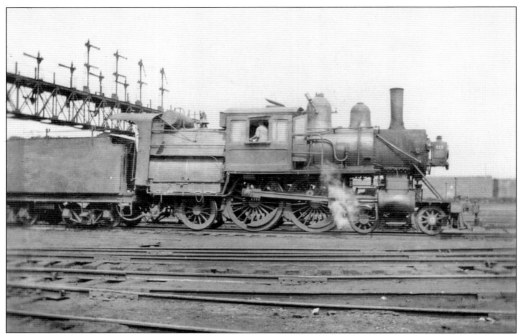

These two images were taken at the Erie's Jersey City yard. Above is the camelback 513 on September 20, 1918. Below is engine 471 on September 3, 1911. Jersey City was reached in 1861 when the 4,600-foot-long Bergen Tunnel was completed. Work on the Jersey City terminal and the tunnel had begun in 1855–1856, and Jersey City remained the eastern terminus for all of the Erie's trains until the merger with the Lackawanna Railroad a century later. With the merger, all services were switched to the Lackawanna's Hoboken terminal. Ferry service, and later the Hudson & Manhattan tubes running under the Hudson River, carried passengers over to Manhattan. (Both, author's collection.)

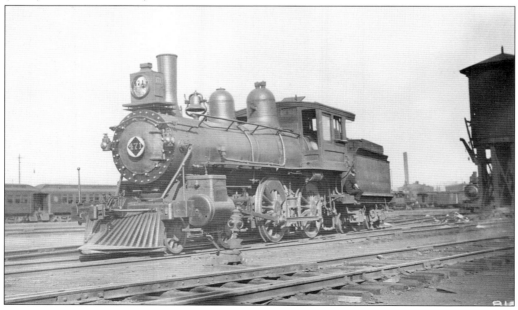

Ten
PHOTOGRAPH GALLERY

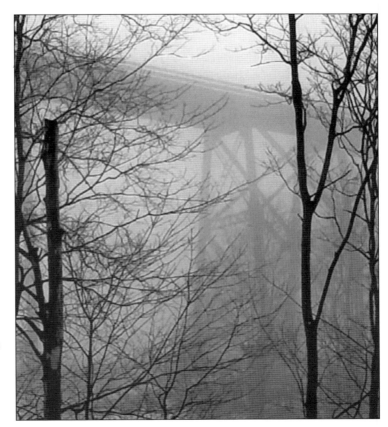

The Moodna Viaduct is shrouded in the fog of an afternoon rain. All times of the year and in all kinds of weather, this 100-year-old trestle never fails to impress the many photographers who come out to capture the engineering marvel from an age long since vanished. (Author's collection.)

The Newburgh branches coursed through countryside that was both historical and panoramic, and this last chapter looks at some of the scenery that the Erie passed through. Seen above is a farm along Woodcock Mountain Road between Salisbury Mills and Washingtonville. A barn on Station Road in Salisbury Mills is seen below. Sadly, this barn has since been lost; it collapsed in a snowstorm not long after this photograph was taken. Beautiful farm scenes like this still dot the landscape in Salisbury Mills and Orange County, but they find themselves biding their time today amid modern development. (Both, author's collection.)

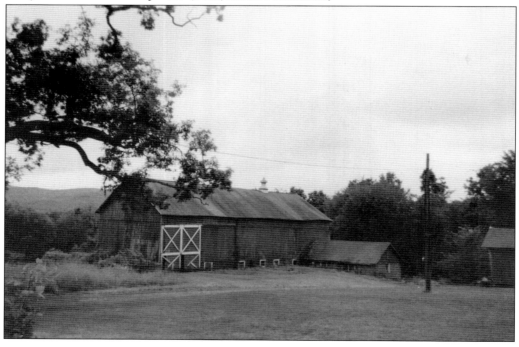

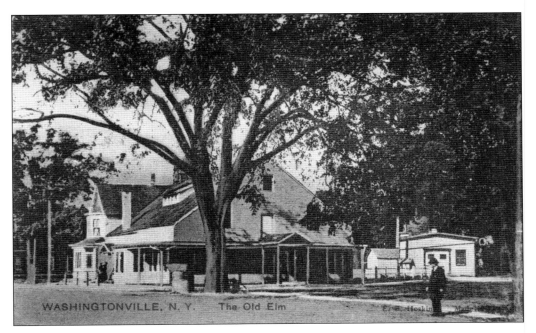

The postcard above of "The Old Elm" in Washingtonville is dated November 1908 and is postmarked from Burnside. It was sent to Col. R.A. Durland of the 161st Calvary in Fort Barry, California. The back of it reads, "Thanks for the postal, I hope you are having a fine time as a soldier—Helen." Today, the area seen in this postcard is the realigned intersection of Routes 208 and 94. Below is Moffat Library in Washingtonville. The library was a gift of railroad magnate David Moffat, who built the library on the site of his grandfather's birthplace. Tiffany windows adorn the library's main room. (Both, author's collection.)

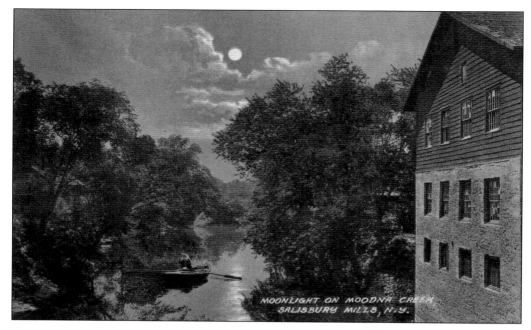

The postcard above paints an idyllic scene of boaters in Moodna Creek behind the paper mill. The speed of the water going over the milldam, which would have been just out of sight in this image, would surely have discouraged recreation such as this in actual practice. The Clove Road Bridge and the Erie Railroad Bridge would be just out of sight up the creek. Below is the Chimney Door Restaurant, a local fixture in Salisbury Mills for generations. This vintage postcard dates to the 1930s. It was never used, leaving history to wonder how far these riders came to take this photograph and eat a hearty meal. (Both, author's collection.)

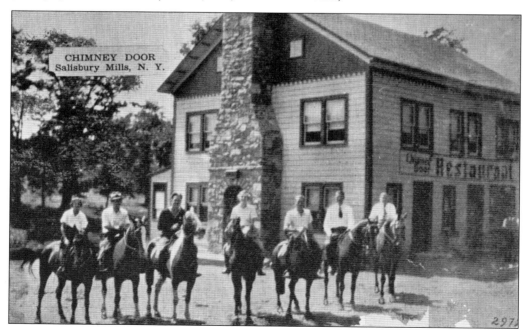

This is the soldier's monument in Salisbury Mills, located at the intersection of Clove and Orrs Mills Roads. The railroad's coal shed is to the left. The monument commemorates the men from Blooming Grove who fought in the War of 1812 and the American Civil War. The first inscription reads: "To the memory of Capt. Richard Caldwell Co. 25th US Infantry and the men from Blooming Grove who fought and died in the War of 1812–1815." The second inscription reads: "To the memory of Isaac Nicolls Col. C. 124th Volunteers and the men from Blooming Grove who fought in the war for the unity of the republic 1861–1865." The monument still stands in its original location, although many of the landmarks around it have long since vanished. The nearby firehouse has monuments to local men who fought and died in the wars that followed. (Author's collection.)

This is Hope Chapel in Salisbury Mills. In Michael Raab's histories on Cornwall for the *Cornwall Local*, he wrote: "Another important enterprise at Salisbury is the present paper mill, situated a little below and near the line of Cornwall. Henry P. Ramsdell is the proprietor. The buildings are of brick, large and commodious. Printing-paper and wrapping-paper constitute the principal line of work. . . . The Methodist Church has a comfortable house of worship. . . . The Presbyterian Church of Bethlehem has also built at this place Hope Chapel, in which Sunday evening services are maintained. The chapel is a neat and convenient edifice, standing on high ground, and is not the least among the attractive features of the village. The cost was about $3000." (Author's collection.)

The Presbyterian Church of Bethlehem, on Route 94 in Salisbury Mills, is seen above. The postcard below shows the original Clove Road Bridge in Salisbury Mills. The sign on the bridge reads, "Two dollar fine for crossing this bridge at a speed faster than a walk under penalty of the law." Noted artist John Gould did a well-known painting of the bridge that replaced this one, with Hope Chapel in the background. The Salisbury Mills Fire Company was founded in 1922 to the right of the bridge. The need for a fire company in Salisbury Mills arose from talk at a ball game being played in town in 1922. The conversation, which led to proceedings for a fire company, was about how the railway depot had recently caught fire and burned down. Through the efforts and diligent work of a few faithful men, the company was formed, and it was well on the way to becoming a reality in 1923. (Both, author's collection.)

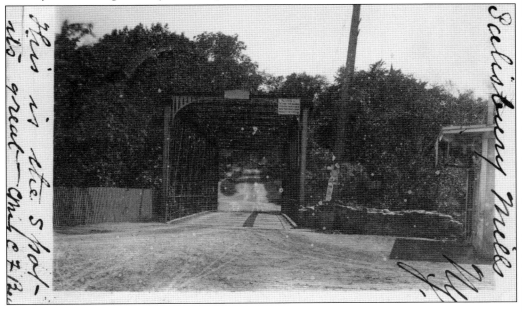

These two views look towards Schunemunk Mountain (above) and the landmark Moodna Viaduct (below). On the ski slope that once existed on the mountain, Harold Sorenson, who had won the New England title in Brattleboro, Vermont, jumped to a height of 181 feet, beating his own record of 177 feet, and scored 224 out of 240 points. This area has been blessed in that much of it has been preserved as public parkland. The trails on the mountain draw scores of hikers to its slopes year-round. In the photograph below, the area just past the telephone pole was once the site of the local schoolhouse. (Both, author's collection.)

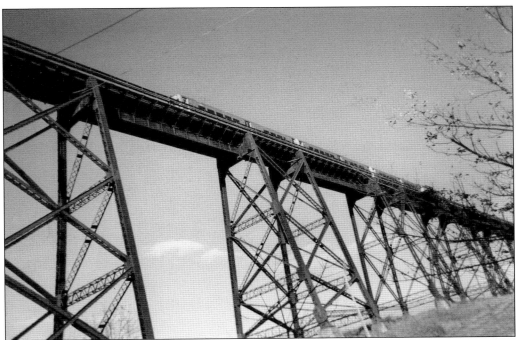

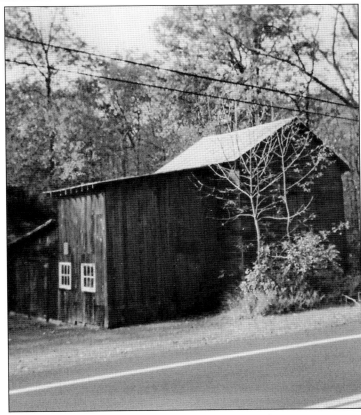

This page is a contrast in time. The image above shows a Metro North commuter train passing over the Moodna Viaduct. Commuter service was switched to the renovated Graham Line in 1983, when the Erie main line was abandoned. The Salisbury Mills/Cornwall commuter station is just past the west end of the viaduct. When the station first opened, its roof had an image built in of an Erie steam engine on the viaduct. Unfortunately, it was vandalized soon after the station's opening and never replaced. At right is a barn off of Orrs Mills Road that has long been a familiar landmark. (Both, author's collection.)

Above is a timeless farm scene on Woodcock Road outside of Salisbury Mills. Below is Clove Road looking towards Schunemunk Mountain. Up ahead is the turn onto Otterkill Road. There, the highway drops down into the valley of the Moodna Creek, and the scenery afforded drivers and hikers alike is unsurpassed. In the Indian language, *Schunemunk* signifies "the mount of the signal fires" because the Native Americans had a castle or palisaded fort on the east end. It was also referred to as Skonnemoghky. In a 1727 deed to Joseph Sackett, the property is described as being on the south side of Skonemugh. In a 1726 deed to Edward Blagg, it is referred to as Schunamock Hill. (Both, author's collection.)

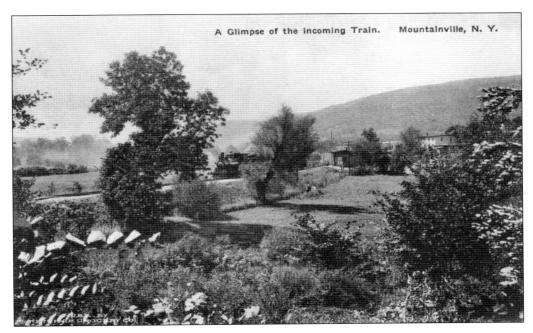

A Glimpse of the Incoming Train. Mountainville, N. Y.

These two postcards show scenes around the Mountainville station in about 1900. The image above, titled "A Glimpse of the incoming train," gives a rare view of the railroad embankment from this side. The image below is actually looking west from the station platform, not east. The station still stands today; it was the public library for many years after the end of railroad service. A road has replaced the rails today, and much of the embankment has been removed. The Mountainville firehouse and post office occupy the area to the left. The feed mill to the right of the tracks is now the Black Rock Fish & Game Club, a landmark that has been a local fixture for generations. (Both, author's collection.)

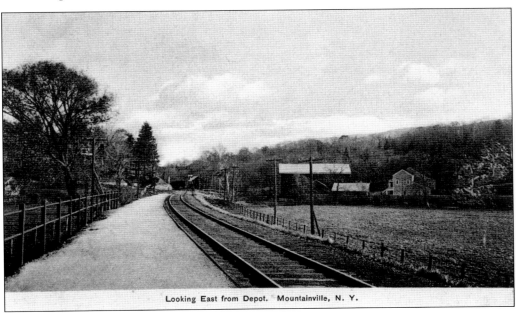

Looking East from Depot. Mountainville, N. Y.

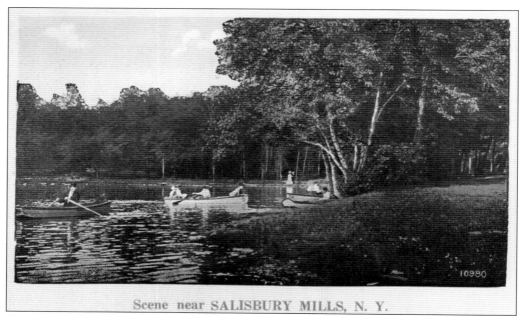

Scene near SALISBURY MILLS, N. Y.

These two postcards are typical of cards from around 1900. They were supported by local businesses to draw visitors with views of the natural and scenic landmarks of the area. Hotels always made sure to promote fishing and boating prominently in their brochures in those days, as fresh air and open countryside were prized as an escape from crowded and dirty cities. With the coming of the automobile age, promoting modern highways became a major business. Railroads made sure that there were penny postcards to sell to travelers at every station stop. In the days of summerlong vacations, these were fondly kept souvenirs in the cold winter months. (Both, author's collection.)

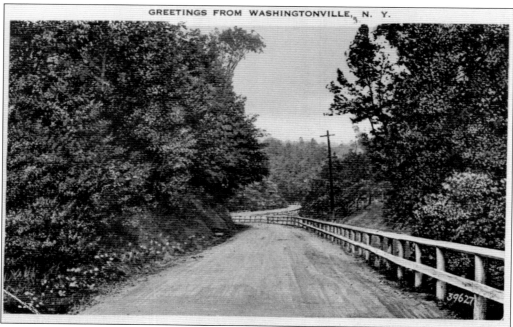

GREETINGS FROM WASHINGTONVILLE, N. Y.

The postcard above shows the Newburgh ferry, as well as the Mount Beacon Monument and Washington's Headquarters in Newburgh. The port of Newburgh around 1900 was a thriving commercial center, with two railroads, the ferry service, and the palatial steamboats of the Hudson River Dayline Company. Trolleys connected lower Newburgh with areas as far out as Walden. Below is a photograph of the Newburgh waterfront and the steeple-topped city from the river. The ferry docks can be seen to the right, along with the passenger terminal. (Above, author's collection; below, Library of Congress.)

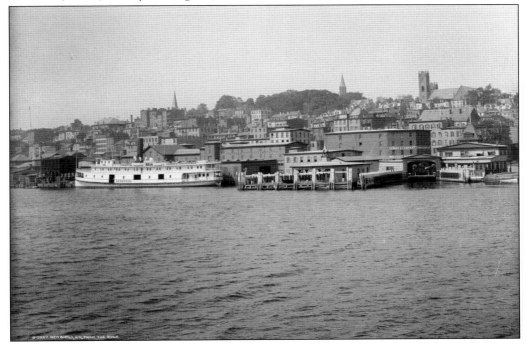

Here is the corner of Water and Colden Streets in the major business center of lower Newburgh. Trolleys were a symbol of a city's status around 1900, and they are seen running down the center of the street. Men wearing derbies wait with their horses and buggies, and there is no sign yet of the "horseless carriage," which for both good and bad changed the economics of Newburgh and the world. The tracks of the West Shore Railroad run behind the buildings on the right on a roadbed elevated above the traffic. (Library of Congress.)

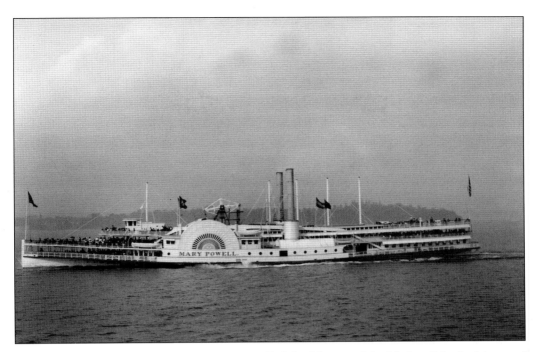

The steamboat *Mary Powell*, seen above, was called the "Queen of the Hudson." In the history of steamboats along the Hudson River, no other steamer gathered the notoriety and affection the *Mary Powell* did. It began its career in the years right after the Civil War and ran faithfully until 1919. It was a fixture on the Newburgh waterfront, and the Powell family was very prominent in Newburgh history. The *Mary Powell* had but two captains for most of its years of operation: Capt. Absalom Anderson and his son Capt. A. Eltinge Anderson. Known as a "family boat," both Captain Andersons saw to it that all passengers conducted themselves properly. If they did not, it was said that they ran the risk of being put ashore at the next landing. Below is a 1905 fare book for the *Mary Powell*. (Both, author's collection.)

RATES OF FARE.

Highland Falls N. Y.	Highland Falls								
West Point "	. .	West Point							
Cornwall "	15	15	Cornwall						
Newburgh "	15	15	15	Newburgh					
New Hamburgh "	40	40	40	25	New Hamburgh				
Milton "	40	40	40	25	15	Milton			
Poughkeepsie "	40	40	40	25	15	15	Poughkeepsie		
Kingston "	50	50	50	50	40	40	25	Kingston	
New York "	75	75	75	75	75	75	75	75	1 00
Return ticket.	1 00	1 00	1 00	1 00	1 25	1 25	1 25	1 50	

Discover Thousands of Local History Books
Featuring Millions of Vintage Images

Arcadia Publishing, the leading local history publisher in the United States, is committed to making history accessible and meaningful through publishing books that celebrate and preserve the heritage of America's people and places.

Find more books like this at
www.arcadiapublishing.com

Search for your hometown history, your old stomping grounds, and even your favorite sports team.

Consistent with our mission to preserve history on a local level, this book was printed in South Carolina on American-made paper and manufactured entirely in the United States. Products carrying the accredited Forest Stewardship Council (FSC) label are printed on 100 percent FSC-certified paper.